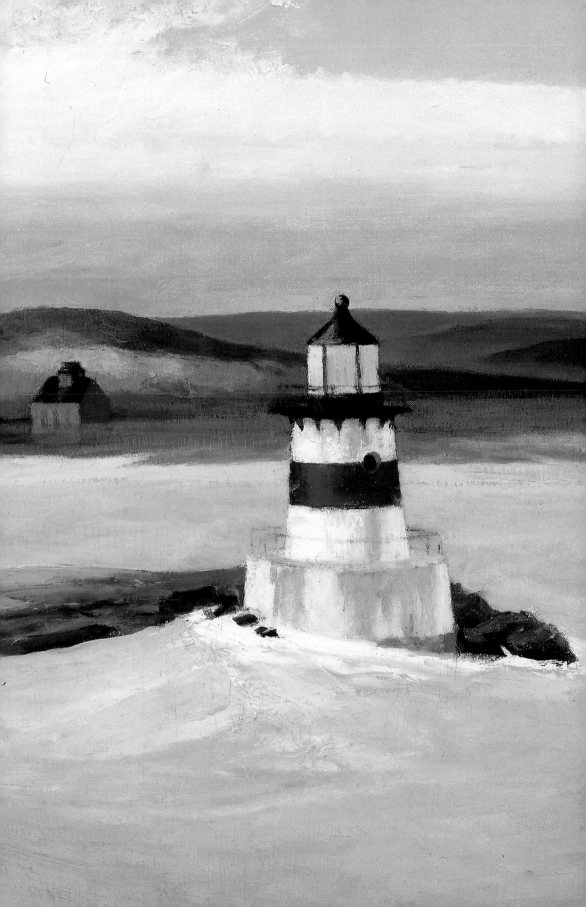

Wieland Schmied

Edward Hopper

Portraits of America

Prestel

Munich · New York

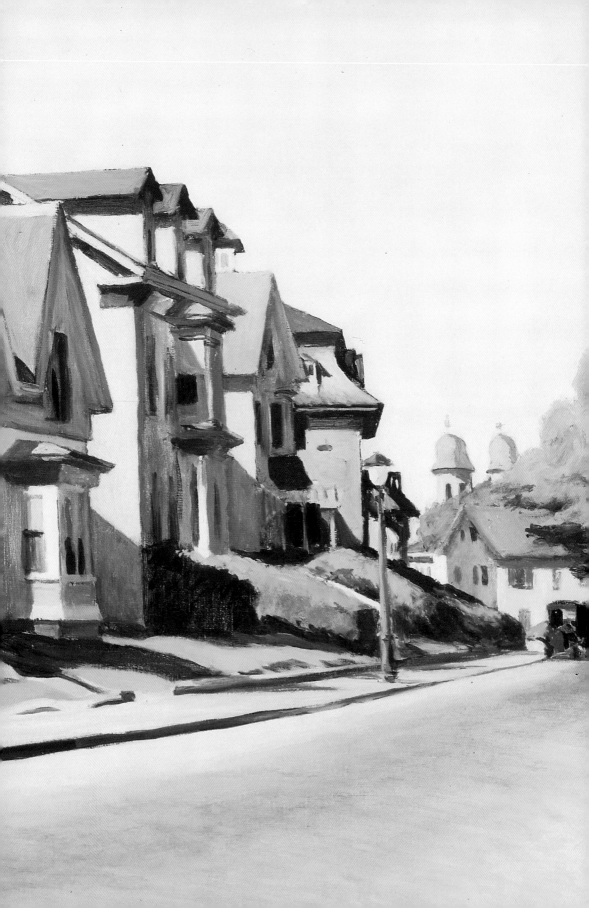

Contents

Edward Hopper's America 7

Street Scene, Gloucester
1934 (detail)

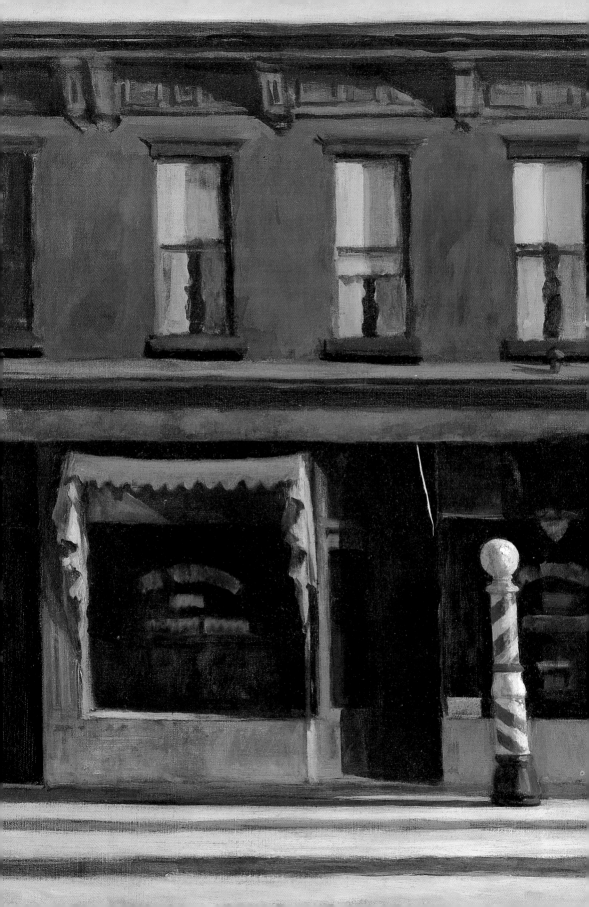

Edward Hopper's America

Edward Hopper is one of the major Realist painters of the twentieth century, and not only in the American context – on this art historians generally agree. But where exactly does Hopper belong? Many commentators – some of them American – associate him as a matter of course with the American Scene, a Regionalist movement of the 1920s and 1930s. But is he a true Regionalist? Is his art great on account of its local color, or despite it? Or is his work not regionalist at all, and those who seek its origins in the American Scene are mistaken?

Hopper had to wait until he was fifty-one for the first large public display of his work, in a retrospective held in 1933 at the Museum of Modern Art, New York. Alfred H. Barr, Jr., director of the museum and author of the catalogue's introduction, called Hopper a typically American painter, which by this point in time was no longer a disadvantage but an advantage. In an homage to Hopper in the same catalogue, his friend and fellow-artist Charles Burchfield stated: "Edward Hopper is an American – nowhere but in America could such an art have come into being."

Just over a year later, in December 1934, *Time* magazine published a cover story on the new generation of painters, entitled "The American Scene." All the artists discussed were Regionalists: Thomas Hart Benton, John Steuart Curry, Grant Wood, Charles Burchfield, and Reginald Marsh. Hopper too was listed, as though his being included was considered to be self-evident. Even Lloyd Goodrich, a former director of the Whitney Museum of American Art who followed Hopper's career from the beginning, placed his subject matter under the heading "The American Scene" in his standard work on the artist, published in 1970. Goodrich had taken the same tack in his first essay on Hopper, dated 1927. "It is hard to think of another painter," wrote Goodrich, "who is getting more of the quality of America in his canvases than Edward Hopper."

So perhaps we should accept this classification, and content ourselves with slight shifts of emphasis – if it were not for the fact that the artist himself strongly disagreed. Hopper refused to be grouped with the Regionalists, most of whose work he did

Early Sunday Morning,
1930 (detail)

not admire. In a conversation with Brian O'Doherty in the early 1960s, Hopper exclaimed: "The thing that makes me so mad is the 'American Scene' business. I never tried to do the American scene as Benton and Curry and the midwestern painters did. I think the American Scene painters caricatured America. I always wanted to do myself. The French painters didn't talk about the 'French Scene,' or the English painters about the 'English Scene'.... The American quality is *in* a painter – he doesn't have to strive for it."

"American Scene" is an elusive term. Its meaning depends largely on the context in which it is used. Generally speaking, it denotes an emphasis on specifically American subject matter, or on the autonomous character of American art, both of which were much in evidence after World War I. Used in a narrower sense, "American Scene" refers to that current in painting of the 1930s which concentrated on rural motifs and celebrated plain, down-home virtues to the point of ideological affirmation. The former definition is broad enough to include the Precisionists, who were fascinated by every aspect of modern technology (Charles Sheeler, Charles Demuth); Realists who were committed to social reform (Raphael Soyer, Ben Shahn); and romantic chroniclers of big-city life (Kenneth Hayes Miller, John Sloan). Despite great stylistic differences, all these artists concentrated on American themes. The second, narrower definition of the American Scene applies to the Regionalist School alone, interest in which had subsided by the end of the 1930s to a largely local level.

However, defined, the concept of the American Scene does have certain points of contact with Hopper's art. Hopper focuses on rural motifs and American small-town scenes as frequently as he does on subjects discovered on his walks through New York. His treatment of such themes, however, shows no trace of the nationalism or narrow-minded "America first" attitude into which the Regionalists sometimes fell.

Nor did Hopper find it flattering to be compared with the great novelists of the Midwest: Sherwood Anderson, Theodore Dreiser, and Sinclair Lewis. He liked Anderson; Dreiser was all right; but Lewis he thought too coarse and satirical. On the whole, he never felt their world to be his. If literary parallels are at all appropriate, they would be with poets, such as William Carlos Williams, e.e. cummings, or Robert Frost (whose

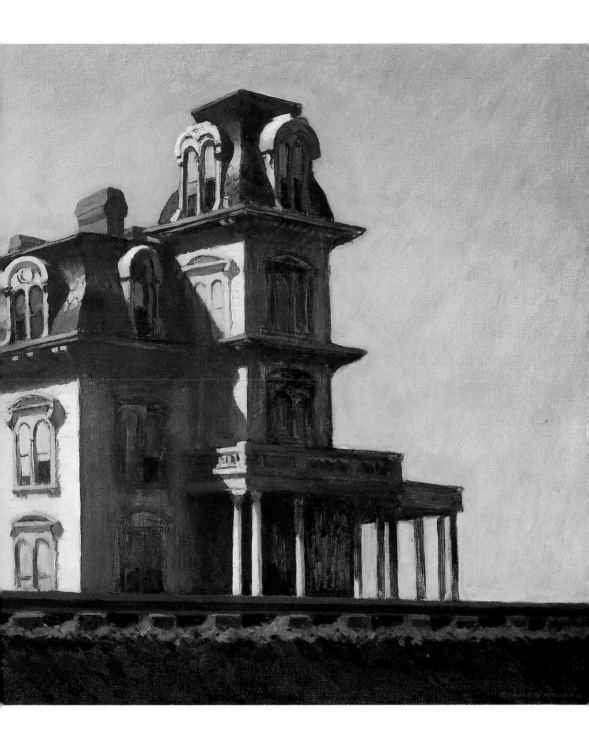

House by the Railroad
1925

verses, according to Brian O'Doherty, Hopper occasionally quoted). Once the artist even gave a written opinion of Ernest Hemingway. In a letter to the editors of *Scribner's* magazine, for which he worked as an illustrator, Hopper praised the laconic tone of Hemingway's short story "The Killers," printed in the March 1927 issue. But the authors with whom Hopper felt the closest intellectual affinity were two American writer-philosophers of the nineteenth century: Ralph Waldo Emerson and Henry David Thoreau.

The question of what is American about Hopper's art is a thorny one. The American quality is obviously there, yet it is difficult to pin down. The more we try to analyze it, the more elusive it seems to become. One thing is clear, however: the pursuit of specifically American traits was not a conscious artistic strategy on Hopper's part. I believe he was motivated by something more general – by an interest in the human condition itself. And being a precise observer, he found symptoms of this universal condition in the specific world of his own day and age. Thus the American quality in Hopper's paintings was unpremeditated, and for that very reason it suffused them so thoroughly that they seem deeply impregnated with it.

The depth of the American dye in Hopper was early recognized by his friend, Charles Burchfield. In the 1933 homage cited above, Burchfield addressed the topic with great sensitivity. After stating that "Nowhere but in America could such an art have come into being," he added: "But its underlying classical nature prevents its being merely local or national in its appeal. It is my conviction, anyhow, that the bridge to international appreciation is the national bias, providing, of course, it is subconscious. An artist to gain a world audience must belong to his own peculiar time and place; the self-conscious internationalists, no less than the self-conscious nationalists, generally achieve nothing but sterility...."

Burchfield's endeavor to locate Hopper's uniqueness led him to this cogent and compelling definition: "He is the pure painter, interested in his material for its own sake, and in the exploitation of his idea of form, color, and space division. In spite of his restraint, however, he achieves such a complete verity that you can read into his interpretations of houses and conceptions of New York life any human implications you wish; and in his landscapes there is an old primeval Earth

feeling that bespeaks a strong emotion felt, even if held in abeyance...."

Hopper, then, was a painter of the American Scene in a very special sense. The houses he depicted are American houses, their interiors are American, and the people who inhabit them are certainly American – restlessly on the move and tired of being restless, lonely and quietly despairing at their loneliness.

There is a timeless quality in the America Hopper depicts. Yet it is actually a quite definite aspect of America, which can be precisely dated in historical time. Hopper records the country as it was in the 1920s and 1930s and his rural motifs especially give a sense of what its atmosphere must have been like around the turn of the century. The America of Hopper's youth had not passed away when he painted it; it merely had been overlain in places with the veneer of the 1920s and 1930s.

Turn-of-the-century America lives on in the rural architecture in his scenes: in the white wooden houses along the street of a small New England town, colonial era Puritanism made manifest; or in the *House by the Railroad*, 1925 (illus. p. 9), a conglomerate of architectural styles wedding Victorian England with France of the First and Second Empires to give birth to an amazingly idiosyncratic whole. The facade and mansard roofs recall the play of light and shade found in the chimneys, projections, and window ledges of the Louvre depicted in Hopper's 1909 paintings *Le Pavillon de Flore* and *Le Pont Royal* (illus. p. 14). This is only one example of the many European reminiscences that entered the scene which, thanks in part to Hopper, has come to be considered so typically American.

The historical America which Hopper began to record in the middle of the 1920s in paintings, such as *House by the Railroad*, continued to preoccupy him to the end of his career. Later developments – the drugstores and neon signs, plate glass windows, shiny cars, and enormous parking lots of the 1960s and 1970s – were left for the Photorealists to depict. The prototypes of this consumer's world, fixed in his mind decades before, sufficed Hopper for a lifetime of work. To the end he remained true to the look of offices or self-service restaurants, country house facades and mansion rooflines, movie theater decor, and gas station design that he had seen in the 1920s and 1930s.

Hopper's paintings take us back to the America of the Great Depression, ushered in by the Wall Street crash of October

Early Sunday Morning

1930

Hopper initially wanted to name
this picture after the street it
represents, for, as he said, it is an
almost literal transcription of
Seventh Avenue. But the more
general *Early Sunday Morning* was
preferred by viewers, and it stuck.
The evocation of the quiet mood of
a city street on a day of rest seemed
more essential than any topogra-
phically exact representation.

 As Gail Levin reports, *Early
Sunday Morning* was inspired by a
stage set. In February 1929,
Hopper had gone to the Playhouse
Theater, New York, to see a per-
formance of Elmer Rice's *Street
Scene*, a Pulitzer Prize winning play.
The stage design, by Jo Mielcziner,
represented the facade of a two-
story tenement that extended the
entire width of the stage. A figure
was visible in one of the second-
story windows. Hopper originally
planned to include such a figure
in his painting, but, as Brian
O'Doherty notes, he later painted
it over.

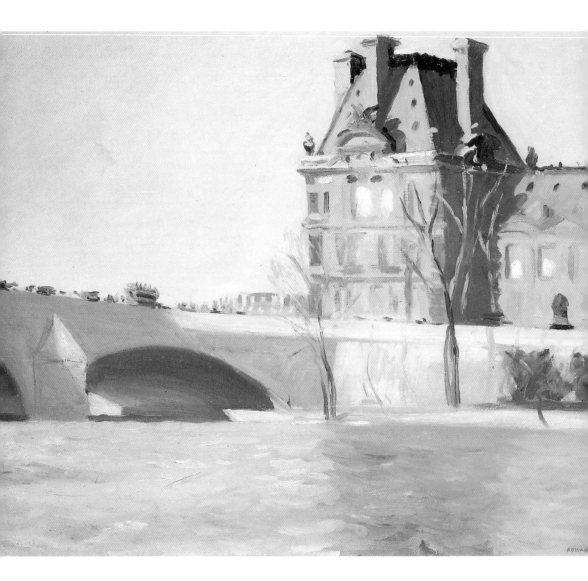

Le Pont Royal
1909

1929, and holding the country in its grip until World War II. Yet this dispirited mood seems to have been innate in Hopper, for he evoked it in paintings done long before 1929. There was no need to alter such compositions to reflect the new circumstances; the new circumstances suddenly lent them currency. Hopper showed people who were worrying about losing their jobs, if they still had one; people who defined themselves in terms of their occupations yet felt oppressed, chained down by them. Evidently, the Great Depression dealt an even more debilitating blow to American self-confidence than the Southern secession and Civil War of seventy years before, or the Vietnam War four decades to come.

Yet Hopper depicted much more than the depression and economic crisis of the 1930s. He depicted the crisis of an alienated world, the loneliness of the human situation in the modern age. He felt this loneliness within himself from very early on, and not even his marriage in 1924 with the actress and artist Jo Nivison – a woman of ebullient temperament – could alter his deep-seated sense of alienation.

Hopper's paintings of the 1930s seem no different in character from those of the 1920s, just as the 1940s and 1950s compositions show little change with respect to earlier work. But when the oeuvre is reviewed as a whole, certain gradual, almost infinitesimal changes do become apparent: towards an increasing economy of means, a waiver of extraneous detail, an emphasis on simplicity of composition, and a growing emptiness. This development culminated in paintings such as *Rooms by the Sea*, 1951 (illus. p. 17) and *Sun in an Empty Room*, 1963, interiors devoid of human habitation. As Hopper's interiors grew emptier, the feeling of loneliness and abandonment they evoked deepened, ultimately becoming a sense of ubiquitous crisis. The economic crisis into which the world was plunged in the 1930s was the crisis of modern life. This is the impression given by Hopper's America, as of a world suspended outside the flux of time.

"I had the great fortune," Italian artist Giorgio Morandi once said in conversation, "of being able to lead a quite uneventful life." Hopper could have said the same of himself. Like Morandi, he saw the superficial uneventfulness of his life as a boon, an advantage worth cultivating. There are many affinities between Hopper and Morandi, including certain parallels between their conceptions of art. But before turning to these, let us look at the surprisingly similar circumstances of their lives.

Like Morandi, Hopper was an introverted man, one of whose most urgent needs was that for privacy. Like Morandi, he led a very disciplined life, devoted principally to his art. And like Morandi, Hopper was a persistent but slow worker whose lifetime production, compared to that of many contemporary artists, was not large.

Neither Morandi nor Hopper was prone to talking about his own work, or made any great effort to achieve financial or critical success (though it certainly did not leave Hopper cold when it finally came). Like the Italian artist, Hopper divided his time between city and country, a circumstance reflected in the motifs

of his art. And like Morandi, he remained faithful to a few familiar places. What the Via Fondazza in Bologna and the village of Grizzana in the Apennines were to Morandi, New York City, South Truro and Cape Cod on the Massachusetts coast were to Hopper. He worked for fifty-four years in the same studio, and lived in the same modest apartment, at 3 Washington Square North, he had moved into in 1913. After his marriage he rented a studio for his wife in the same building. Hopper first visited South Truro in 1930, then bought a piece of property there in 1933, and had a studio built to his own design the next year. From then on, until 1966, he spent the summer and fall months of every year in South Truro. In one respect, however, the two artists differed. Morandi spent his entire life in Bologna and the province of Emilia. Hopper, despite his strong roots, loved to travel. As a young man, he regularly went on long jaunts through the New England states, especially Maine. Beginning in 1925, he and his wife made six trips in their own car to the Southwest, one to Canada, and five to Mexico, where they visited Saltillo, Monterrey, Mexico City, and Mitla-Oaxaca.

More salient than the obvious similarities in character and life-style are the parallels between Hopper's and Morandi's artistic development – their related, if by no means identical, conceptions of realistic art. The work of both was initially shaped by an involvement with late nineteenth-century French painting. But unlike Morandi's, Hopper's confrontation with French art, prepared for by his studies in New York, came not at home but in Paris, where he made three stays of several months each between 1906 and 1910. Hopper had to pass through the Ecole de Paris before he could discover the American scene and develop his own, inimitable vision and style.

Born in 1882 in Nyack, a small town on the Hudson River about forty miles north of New York City, Edward Hopper was the son of a local businessman. After spending a brief period at a school for illustrators, he attended the New York School of Art from 1900 to 1906. His teachers there were William Merritt Chase, Kenneth Hayes Miller, and Robert Henri. Henri, above all, became important to Hopper, not so much in artistic as in personal terms, for Henri was a man who set high standards for himself and his students. It was also he who pointed out that everyday American life contained an inexhaustible reservoir of new and untried subject matter.

Rooms by the Sea
1951

Robert Henri has gone down in art history as a co-founder of The Eight, a group of artists who in spring 1908, prevented from exhibiting in the prestigious National Academy of Design, mounted their own show at the Macbeth Gallery, New York. Their subject matter, though not really so radical as they themselves claimed, soon led the critics to dub them the Ash Can School. Convention now has it that their emergence marked the beginning of an independent, American painting. Seen in historical perspective, however, the independence of the Ash Can School was relative at best. Granted, most of their motifs were taken from the contemporary big-city ambience – New York in the grip of rapid industrial and social change – but this subject matter did not automatically make them revolutionary. Nor was their painting style revolutionary, as it grew out of an attempt to create a synthesis between the American and European traditions. Henri's idols included Thomas Eakins, who was probably the most significant realist painter America produced during t he nineteenth century (and who, unlike Henri, was truly radical if not revolutionary in many aspects of his work, both as artist and teacher). In addition to Eakins, Henri valued Winslow Homer and James Abbott McNeill Whistler, whose art in turn represented a synthesis of American and French approaches, in so far as it was not beholden entirely to the European tradition.

Henri set European masters on a par with the American artists he admired, even giving them priority, and that not only in chronological terms. In the late 1880s and the middle of the 1890s, Henri had studied in Paris for extended periods, responding to the call of France like many American artists of the day, before returning home with a renewed consciousness of their American roots. To his students, Henri extolled the old and modern masters who meant so much to him: Rembrandt, Frans Hals, Velázquez, Goya, Manet, Degas, Daumier – an odd mixture, but indicative of the eye of a born realist who was interested above all in the representation of the human figure.

It was very likely Henri who awakened Hopper's lifelong admiration for the art of Thomas Eakins. Hopper admired his teacher as well, but more for his enthusiasm and the encouragement he gave to his students than for his art. In that regard, Hopper greatly preferred the younger John Sloan, another member of The Eight, whom he met in 1904. In his New York street scenes, Sloan pursued the contemporary motifs proclaimed by

Henri with much greater consistency and stylistic independence than their common mentor. Sloan made such a lasting impression on Hopper that in the 1920s he overcame his typical reluctance to commit himself in writing and devoted a sensitive essay to him. This essay, like a contemporaneous one on Charles Burchfield, has a confessional character, reading in part as if Hopper were speaking about himself.

Being a student of Robert Henri, Hopper was almost preordained to go to Paris. His initial stay lasted from October 1906 to August 1907. Unlike his teacher, Hopper did not enroll in a school or academy, but conducted his studies in museums and on the streets. He returned to Paris twice, in 1909 and 1910, for brief stays. In the meantime, he had embarked on a career in New York as an illustrator and commercial artist, which permitted him to devote half the week at most to his painting. This is apparently why Hopper's Paris production was much more extensive than the series of canvases done in New York between 1908 and 1910.

The key accomplishment of the early period was an assimilation of Impressionism. Hopper's palette grew lighter, his brushwork freer, and his observation more precise. His approach to motifs began to show a growing independence from any model or ideal, both in the American subjects and the Paris ones. Under the Impressionist spell, Hopper discovered the unique light of Paris: "The light was different from anything I had known," he later recalled. "The shadows were luminous, more reflected light. Even under the bridges there was a certain luminosity."

From Paris Hopper undertook trips to Amsterdam, London, Brussels, Berlin, Madrid, and Toledo. In the Netherlands, apart from Rembrandt, he discovered Jan Vermeer as a painter of spiritual illumination and an incomparable master of the intimate interior. Among French painters, Hopper was impressed by Manet and Degas, Pissarro and Sisley, but the deepest involvement came with the work of Monet and Cézanne. Fauvism and the beginnings of Cubism, on the other hand, seem to have escaped Hopper's notice. His preoccupation with the great masters, among whom the Impressionists were already beginning to figure, apparently led Hopper to overlook the contemporary avant-garde. "Whom did I meet? Nobody," he later admitted. "I'd heard of Gertrude Stein, but I don't remember having heard of Picasso at all. I used to go to the cafés at night and sit and

Manhattan Bridge Loop

1928

Hopper described the emergence of this painting in a letter of October 29, 1939, to Charles H. Sawyer, then director of the Addison Gallery of American Art: "I spend many days usually before I find a subject that I like well enough to do, and spend a long time on the proportions of the canvas, so that it will do for the design, as nearly as possible what I wish it to do. The very long horizontal shape of this picture... is an effort to give a sensation of great lateral extent. Carrying the main horizontal lines of the design with little interruption to the edges of the picture, is to enforce this idea and to make one conscious of the spaces and elements beyond the limits of the scene itself.... The picture was planned very carefully in my mind before starting it, but except for a few small black and white sketches made from the fact, I had no other concrete data, but relied on refreshing my memory by looking often at the subject.... The color, design, and form have all been subjected, consciously or otherwise, to considerable simplification" (quoted in Lloyd Goodrich, *Edward Hopper*, New York, 1989, pp. 163-64).

watch. I went to the theater a little...." Motifs of the type he depicted in Paris were to remain central throughout his career: buildings and streets, bridges and rivers, trees, parks, people on the move or just sitting and watching. But the inimitable quality in Hopper's work, his unique viewpoint, had yet to become fully apparent.

Although Hopper's style was crucially shaped by the Paris experience, it still lacked the precision and decision that would characterize it from the 1920s onwards. Perhaps he had grown all-too accustomed to the mild Paris air, for when he returned home for good, America came as a shock: "It seemed awfully crude and raw here when I got back. It took me ten years to get over Europe."

Two canvases of 1908 depict a motif that was later to capture Hopper's imagination: the railroad. *The El Station* (illus. pp. 24-25) shows a station on the old New York rail transit system, and *Railroad Train* represents a passenger train running out of view at the right edge of the canvas, red tail lights gleaming on the last car. The smoke plume streaming across the upper half of the composition, the slight left-to-right downgrade of the tracks, and the windblown wheat field all serve to underscore the impression of movement.

The paint application reflects the new freedom Hopper had gained in Paris. It is brushwork of a kind generally known as "painterly," and at all events, it is much softer and more fluent than in the work of Hopper's maturity. The figures are suggested with a great sureness of hand; details are simplified and merged into larger formal elements. Each individual brushstroke exists in and for itself and remains entirely visible. Divorced from direct description, the strokes are used to articulate expanses of surface and lend them tension. This accentuated brushwork draws the viewer's attention to the actual making of the picture, the process involved. It is as though Hopper were telling us, "Look, a work of art possesses its own reality independent of the external reality to which it refers – it exists in its own right." This insight was, in fact, the quintessence of Hopper's Paris experience of 1906-07. Some time would pass before he realized that autonomy of the painted surface was perhaps not the ultimate end of painting, and that other alternatives existed – especially if one were out to cast off the French tradition and produce an art that was new and entirely personal.

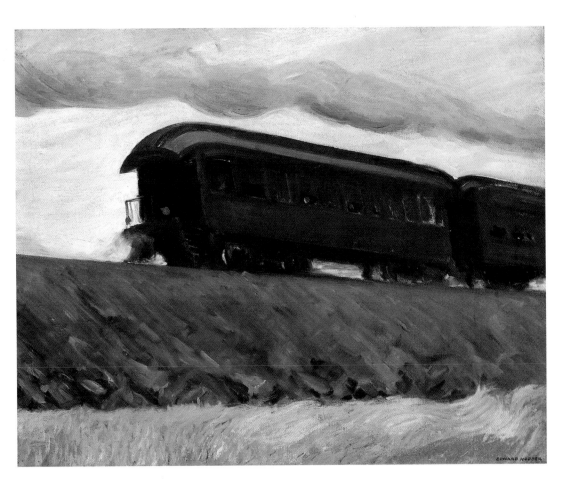

Railroad Train
1908

In two canvases done after his final return to the United States, Hopper addressed a subject that to many artists of the day seemed a prime symbol of technological progress: modern bridge construction. While in *Blackwell's Island*, 1911 (illus. p. 27) the bridge plays only a subordinate role, being literally pushed to the canvas edge, in *Queensborough Bridge*, 1913 (illus. p. 28) it extends dominatingly across the entire composition.

Hopper's vision of Blackwell Island appears to reveal the influence of Whistler's *Nocturnos*. It is a reply to Henri's well-known painting of the same motif (1900), further variations on which would later be supplied by George Bellows, John Sloan, and other members of the Ash Can School. Hopper takes a bird's-eye view that gives us the giddy feeling of standing high up

The El Station
1908

on the left end of the bridge.)He evokes the twilight hour over the East River, an atmosphere into which reminiscences of evenings on the Seine certainly enter. Seventeen years later Hopper would depict Blackwell Island again. This time he left out the bridge, deprived the island of every romantic echo of his transition period, and placed it firmly in the present-day context.

Queensborough Bridge, similarly, has nothing heroic about it despite its gigantic scale. Unlike many artists of the day, Hopper was never tempted to sing the praises of modern engineering. Even the ironic Marcel Duchamp, two years after arriving in New York in 1915, declared that "The only works of art America has produced are its sanitary installations and its bridges." And Joseph Stella, anything but ironic, was soon to lend his visions of the Brooklyn Bridge veritably religious overtones (see illus. p. 26). The lights of Manhattan, viewed through a slender Neo-Gothic arched pier supporting the steel suspension cables, gleam as if seen through a stained-glass cathedral window. Stella transforms the Brooklyn Bridge into a path to a New Jerusalem, the promised city of the future in steel, glass, and electricity.

This belief in progress, shared by many of Hopper's contemporaries and not foreign even to the Precisionists of the 1920s, ran counter to his skeptical nature. *Queensborough Bridge* shows no sign of an enthusiasm for technology. The bridge extending diagonally into the background provides Hopper with an opportunity to depict atmospheric phenomena, to let near objects

JOSEPH STELLA
Brooklyn Bridge
ca. 1919

CLAUDE MONET
*Waterloo Bridge,
Gray Day*
1903

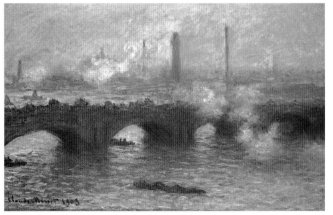

Blackwell's Island
1911

Queensborough Bridge
1913

merge gradually with more distant ones – just as Claude
Monet did with such virtuosity in his series of Waterloo Bridge
paintings around the turn of the century (see illus. p. 26). And
as if offhandedly, Hopper confronts the soaring steel structure
with a tiny boat house and a gabled wooden residence, relics
of a passing era which the bridge might overtop, but cannot
overcome. From the evidence of the picture, it is difficult
to infer whether Hopper's sympathy lay more with the old or
with the new. Like Monet, Hopper organically integrates
technology into the natural realm. Later he would view this
relationship between nature and the work of human hands in a
different light.

In a canvas like *Road in Maine*, painted in 1914 (illus. p. 33), the artifacts of civilization – the ribbon of road and the serried, parallel line of telegraph masts – seem, if not an organic part of the landscape, then incursions which nature has been able to digest. In terms of paint handling, *Road in Maine* still belongs to Hopper's early phase. Like the concurrent *Rocks and Houses, Ogunquit* and *The Dories, Ogunquit* (both also done in summer 1914; illus. p. 32), this canvas shows Hopper testing the artistic experiences of the Paris period by returning to a careful observation of nature.

A comparable sense of reconciliation between nature and civilization is found in landscapes by Morandi done at about the same period. Let *Paesaggio* of 1913 stand as one example for many (illus. p. 32). It depicts a country road with a few houses partially obscured by trees in the right background, and a telegraph mast to the left. More clearly than with Hopper, the origin of the landscape treatment here is evident – the work of Paul Cézanne, who was long an all-powerful father-figure for Morandi. While *Road in Maine* shows Hopper beginning to bring the free brushwork he had developed in Paris under control, Morandi's landscapes of 1910 to 1914 almost revel in liberated paint handling. Hopper's canvas lays claim to its own, intrinsic reality – and yet remains strangely tied to the actual landscape represented. Morandi had to pass through the experience of *pittura metafisica*, in the shape of works done in Ferrara by Giorgio de Chirico and Carlo Carrà, before he was able to arrive at the "solidity of things," the clearly defined, contoured objects that characterized his later oeuvre.

A second pair of later examples may serve to round off the comparison between Hopper's and Morandi's approaches: *Burly Cobb's House, South Truro*, ca. 1930 (illus. p. 34) and *Paesaggio*, 1925 (illus. p. 34). Burly Cobb's House, where Hopper spent his first summer in South Truro, is depicted frontally, like the country house in the Apennines in Morandi's painting. Yet while Hopper is characteristically concerned with architectural design and detail that emphasize the individuality of the building, Morandi simplifies his house to represent a general type. Still, *Burly Cobb's House* does approach Morandi's bare, frequently windowless structures, being less idiosyncratic than most of Hopper's buildings. The most remarkable feature of the farm

Gas

1940

The highway apparently ends here,
disappearing into the woods – not a
promising location for a gas station.
The last car seems to have pass-
ed long ago; the attendant is shut-
ting down the pump, and soon will
turn off the lights and lock up for
the night.

Hopper's painting represents a
borderline situation. It is set at the
frontier between day and night,
between civilization and nature.
The gas station has the appearance
of a last outpost, where the human
realm gives way, across the road, to
the anonymous realm of nature.
The edge of the woods rises like a
dark wall in which no individual
tree can be discerned. But our eye
returns again and again to its warm
hue. The bright, almost pure white
fluorescent light in the gas station,
in contrast, is almost painful to
look at, and the eye shifts to the
ribbon of road leading out of the
picture to the right.

Yet the interest of this lonely
outpost proves too great. The
exaggerated perspective of the lane
between grass-grown margin and
mast draws us irresistibly into the
narrow aperture, into a gloom from
which there would seem to be no
escape.

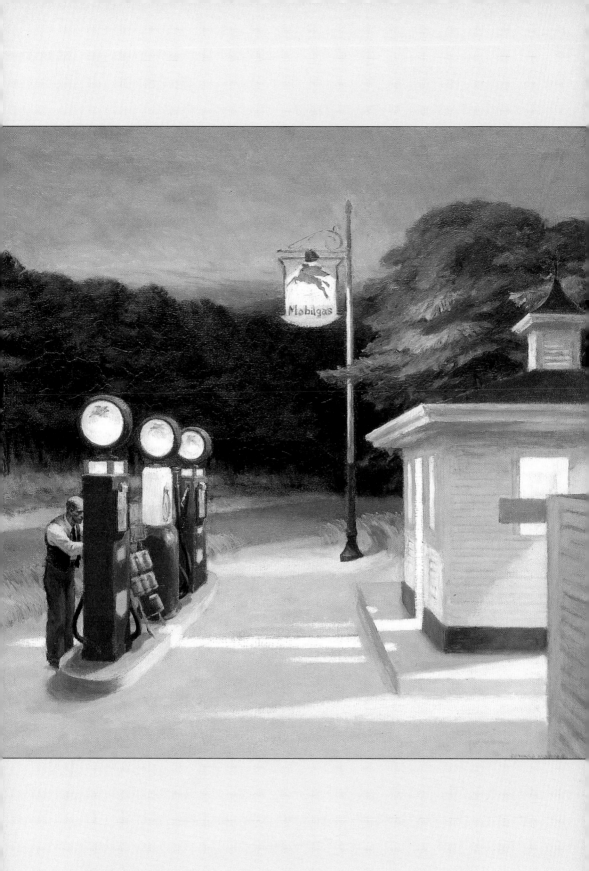

The Dories, Ogunquit
1914

GIORGIO MORANDI
Paesaggio
1913

Road in Maine
1914

seems to be the angular outbuildings with their interlocking roofs.

Although the two pictures have many characteristics in common, closer scrutiny reveals considerable differences. Yet both Hopper and Morandi were concerned not only to depict external reality, but to convey the emotions it engendered in them. As Morandi said, "The possible educational function of visual art consists in communicating the images and the feelings engendered in us (the artists) by the visible world. That which we see in the process is what I call the artist's creation or invention."

Hopper expressed himself in similar terms: "My aim in painting has always been the most exact transcription possible of my most intimate impressions of nature." And, in another place, "Great art is the outward expression of an inner life in the artist, and this inner life will result in his personal vision of the world...."

33

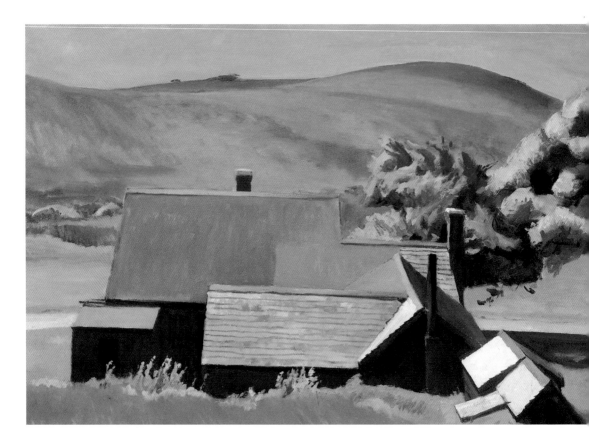

Burly Cobb's House,
South Truro, 1930-33

GIORGIO MORANDI
Paesaggio, 1925

GIORGIO MORANDI
Paesaggio, 1943

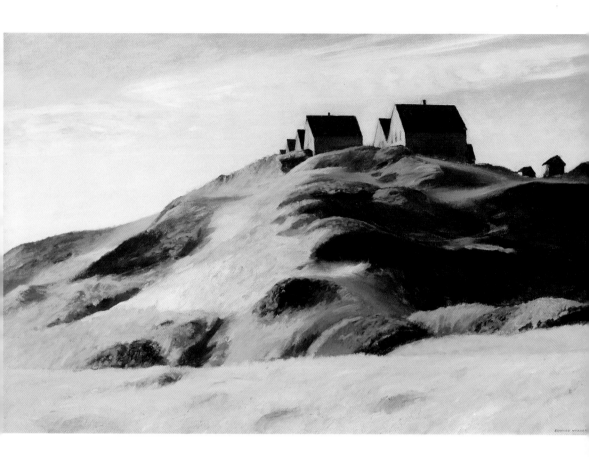

Corn Hill
1930

As close as the affinities may seem between Hopper's New England landscapes and Morandi's Apennine scenes, the points of divergence cannot be overlooked. Morandi, both in his still lifes and his landscapes – simple arrangements of a house, a tree, a hill – seeks to distill form from random appearance. It is for the sake of form that he looks at a landscape, studies objects. Hopper, in contrast, is concerned to pin down, through form, the uniqueness of objects, the specific character of a certain landscape.

The most salient difference between the two artists, however, lies in their approach to light. In Morandi's works we sense a harmonious relationship between light and visible things, a harmony so great it could even be termed a unity of light and the world. The light penetrates, suffuses every form; it seems to illuminate things from within, become one with the matter of which they are composed. This is why Morandi's illumination appears so diffuse and substantial – it is inseparable from

objects. It appears to originate from the depths of the things depicted.

In Hopper's work, by contrast, the distinction between light and illuminated things is never overcome. The light impinges harshly on objects, highlighting portions of them and plunging others into deep shadow. Instead of merging with things, it remains external to them. The light is reflected, and it often seems to glide off the objects in his paintings as if it could find no hold on them.

This characteristic treatment of light is particularly obvious in two canvases: *Lighthouse Hill*, 1927 and *The Lighthouse at Two Lights*, 1929 (illus. p. 38), both painted outdoors at Cape Elizabeth, Maine. The lighthouses are so dramatically rendered that they suggest a setting for an Ibsen play. The light reflected from the walls has nothing of the warmth of Morandi's illumination. It is so cold it almost makes one shiver. The white in these passages contains only a very small admixture of yellow, a method of rendering reflected light that Hopper would later develop to perfection, as in *Second Story Sunlight*, 1960 (illus. pp. 98-99).

A closer parallel than with Morandi for the illumination of Hopper's lighthouses is found in another Italian's paintings: Giorgio de Chirico's *The Great Tower*, 1913 (illus. p. 38), or *Yearning for the Infinite*, 1913-14 (illus. p. 39). De Chirico's light invariably has an artificial look, as if produced by floodlights on a stage. His metaphysical reality is a reality of appearances, and like the theater, it signifies the world. De Chirico's light sources generate blinding brightness and deep shadows, but they convey no warmth. The light is merciless, giving us as viewers the feeling of being suspects under cross-examination, a desk lamp turned full in our face.

In a sense, Hopper translated de Chirico's artificial world back into natural terms. He experienced de Chirico's dream visions in face of reality. But the coldness and eerieness remained. Looking at the lighthouse pictures, we have the impression of actually feeling the frigid evening breeze off the ocean on our skin, and only the lee of the hill beneath the tower seems to offer a little shelter.

But this is to anticipate things to come. Let us return to the period in which Hopper painted *Road in Maine*. He had yet to develop his mature style; he was still involved in tentatively finding his way back from the harmony of the Paris atmosphere

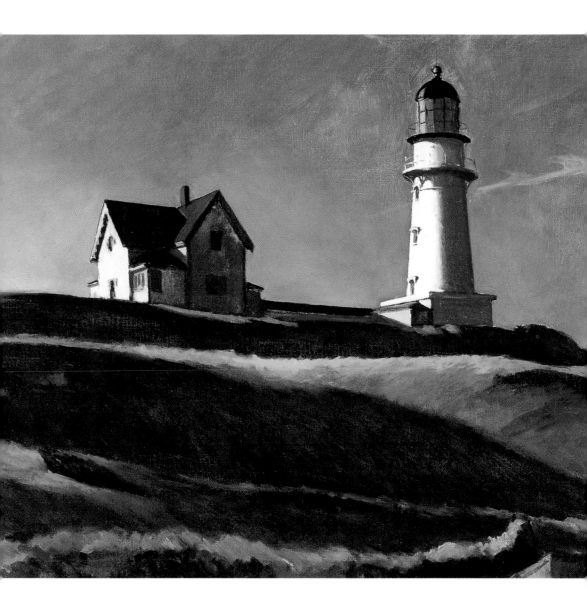

Lighthouse Hill
1927

to the "crude and raw" conditions of his own country, in an attempt to locate a place for himself there. Still strong in his mind were experiences of the kind he had described to his mother in a letter from France: "Paris is a very graceful and beautiful city, almost too formal and sweet to the taste after the raw disorder of New York. Everything seems to have been planned with the purpose of forming a most harmonious whole which certainly has been done."

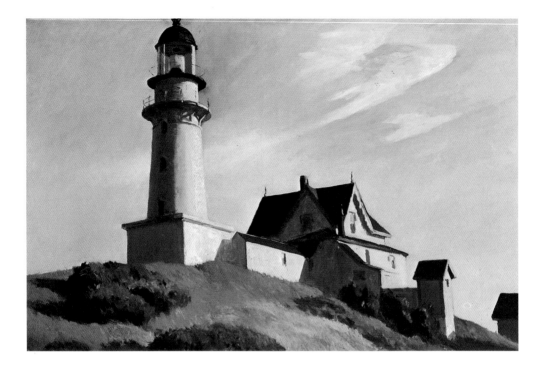

The Lighthouse
at Two Lights
1929

GIORGIO DE CHIRICO
The Great Tower
1913

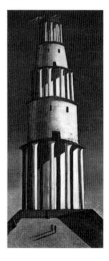

The beauty of Paris – and of French art – shaped Hopper's early style. And he soon realized that if he wished to do justice to the quite different character of what preoccupied him about America, this style would have to be altered. Not only was the American light different from that of the Ile de France; peoples' habits and movements, indeed the entire rhythm of life, was a far cry from the harmony he had sensed in the Paris scene and temperament.

Hopper discovered his own America by observing people around him – how they moved and how they rested, how they lived and worked. In Paris he had noted, "The people here in fact seem to live in the streets, which are alive from morning until night, not as they are in New York with that never-ending determination for the 'long-green,' but with a pleasure loving crowd that doesn't care what it does or where it goes, so that it

has a good time." By comparing the goals and life-style of New Yorkers with the life he had experienced in Paris, with the natural French gift of *joie de vivre*, Hopper gradually became aware of the meaning of alienation. And with this awareness came the discovery of his great theme.

Assistance in this regard came from a quarter he himself would have least expected: his work as an illustrator. Hopper hated it, and later talked about it only with the greatest reluctance. To him illustrating was a way of making a living – nothing more. His deepest urge, his true work, was painting, but he was continually prevented from devoting himself to it by the magazine commissions he received, and which he needed in order to survive. Illustrating seemed pure slavery to Hopper, alienated labor. Yet it was labor that helped him to find his own style, and thus to find himself.

Until 1924, the year of his first one-man show in a private gallery, Hopper was able to sell only two paintings: *Sailing*, sold for $250 at the 1913 Armory Show, and a watercolor, *The Mansard Roof*, purchased for $100 by the Brooklyn Museum in 1923. Commercial art provided him with an income. When he returned from his first Paris trip in 1907, Hopper took a job as illustrator for the Sherman & Bryon advertising agency. Although it was an activity he did not enjoy, he was very successful at it. By 1912, in addition to designing advertisements, he had begun con-tributing illustrations to periodicals such as *Sunday Magazine*, *The Metropolitan Magazine*, *Everybody's*, *System*, and *The Magazine of Business*. Subsequently his clientele expanded to include *Scribner's* magazine, *Farmer's Wife*, and *Country Gentleman*, as well as corporate organs like *Wells Fargo Messenger*, *The Express Messenger*, *Hotel Management*, and *The Morse Dry Dock Dial*, for all of which he designed covers (see illus. p. 40).

Hopper's illustrating activity entailed a close observation of people (though buildings and landscapes would probably have been more to his liking). The magazines wanted pictures in which their readers could recognize themselves and their environment. And Hopper complied with the editors' wishes. Innately self-disciplined, he observed the everyday life around him with an eye to capturing typical aspects of the day and age. Though he could not bring himself to depict the waving, grinning, gesticulating people the editors would have liked to see, preferring quiet, almost meditative situations instead, Hopper's

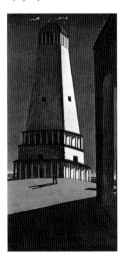

GIORGIO DE CHIRICO
Yearing for the Infinite
1913-14

study of daily life was an intensive and thorough one. And since he addressed every task, no matter how unimportant, with great earnestness, this could not remain without consequences for his art. Thanks to his illustrating work, Hopper not only learned to convincingly embed the human figure in a contemporary context, but to associate the figures with various occupations and pastimes familiar to every reader. He depicted people talking at a restaurant table, in the office, or on the street, people riding on the subway, people playing sports. At the same time, he learned to use references to the current ambience sparingly, to tell a story with great economy of means – the art of omission and allusion.

Illustration from Victor Hugo's
Les Misérables
ca. 1900-09

The phase of commercial art work lasted to the middle of the 1920s, when Hopper's sales of oils and watercolors at last enabled him to give up illustration. They were years of self-discovery. Hopper's paintings began to take on the character of illustrations in reverse, illustrations without a subject predetermined by others. They amounted to an artistic declaration of independence. Hopper said good-bye to tritely narrative themes, turned the tables on his clients, went on the offensive. Previously compelled to invent pictures to fit other people's stories, now he challenged other people to find stories to fit his pictures. This plunged his viewers into a dilemma.

On first sight it seems easy to think up a plot for Hopper's scenes, but the impression is misleading. The very ease of the process lures us into error. It is like trying to win at poker – so much depends on the fall of the cards. And Hopper, who seems to put all his cards on the table, actually reveals very little about his strategy. And he often purposely feints, to put us on the wrong track.

Illustration from Victor Hugo's
collection of poems entitled
L' Année Terrible,
ca. 1906-07

Take Hopper's figures, about whose stories he gives us a few, tempting hints, suggesting fates which seem to be hidden just beneath the surface. And this suggestion touches us, arouses our interest and concern. But how are we to define what we see? As soon as we begin, we realize how little we know about the reality depicted – as little as we know about people met on the train, in a cafe, or at a party. Hopper provides only a scant few details, but they are details charged with significance. More than a paucity of clues, it is this abundance of suggested meaning that makes it so difficult to say anything about Hopper's pictures. Their surface proves impenetrable. We cannot see what lies beneath. We begin to wonder whether it is possible to do what the paintings seem to

demand – to imagine the stories of the people who appear in them. The deeper we attempt to penetrate into Hopper's world, the more hermetic it becomes. In the end is silence.

A further step towards self-discovery came with etching (see illus. below). From 1915 to 1923 Hopper created about seventy-five images by this technique (including posthumously printed plates). As in the case of illustration, his initial reason for turning to etching was a practical one: a way to earn money, as well as to make contact with galleries and perhaps be included in serious exhibitions. His etchings were well received, strengthening Hopper's belief in himself as a fine artist, and encouraging him to continue painting. The demanding technique of etching, he later noted, helped him to achieve greater focus and concision in his oils.

What he owed in the way of content to his activity as an illustrator – precise observation and description of contemporary big-city life – Hopper owed to etching in the way of form. In the process of creating an etching, he learned to place diverse scenes of the kind he had depicted in his illustrations into the context of a composition, to integrate figures, objects, and setting in an overall hatched pattern (sometimes reminiscent of Morandi's etchings), and to embed them in the interpenetrating zones of light and shade that fill a printed sheet to its edges.

House on a Hill
(The Buggy)
1920 (?)

New York Movie

1939

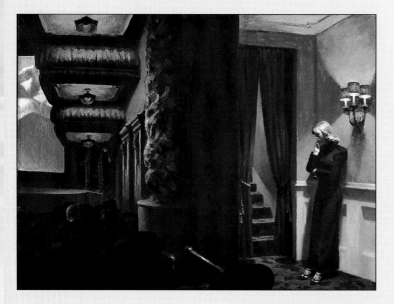

A movie theater in New York, one of those elaborate mock palaces where Hollywood spirits us for a few hours into another world – in this case apparently the high mountains. Spirits us as audience, that is, but not the usher, who has probably seen the movie a thousand times and waits for the curtain, mulling over her own thoughts. Her stationary figure counterpoints the screen with its incessantly flickering illusions of places not here and not now.

Like most of the female figures in Hopper's paintings, this one was based on his wife, Jo, who posed standing under a lamp in the hall of their apartment. Her efforts were perhaps rewarded by the many movie and theater visits the couple made together.

As the many preliminary studies for the picture show, Hopper not only drew his wife in various different poses for *New York Movie*, but precisely designed the auditorium decor, down to the pattern of the carpet. Again and again he sketched the foyers, stairways, and auditoriums of his favorite movie houses, the Palace, Globe, Republic, and Strand.

The relationship between Hopper's illustrations and his etchings resembled that between his later watercolors and oils. The illustrations were based on sketches or emerged from direct observation of reality, while the etchings were made in the studio. The scenes Hopper now began to render involved a high degree of invention, based on a sum of previous visual experiences. In addition, he was continually concerned to find new and unusual vantage points. Later, discussing the role of etching in the life's work of his friend, John Sloan, Hopper described printmaking as a training in invention of the kind a pure painter would seldom accomplish.

In an often-quoted statement made to Lloyd Goodrich, perhaps prompted by the torment of having to comply with editors' demands to depict "people waving their arms," Hopper admitted: "Maybe I am not very human. What I wanted to do was to paint sunlight on the side of a house." What this implies, I think, is that rather than concentrating on human beings and their activities, Hopper was more concerned with the meditative aspect of the world, which sunlight on the side of a house would be sufficient to evoke. Perhaps he was thinking along similar lines to Giorgio de Chirico, who once said, "In the shadow of a man walking in the sun there are many more riddles than in all religions of the past, present, and future."

The human quality was no more alien to Hopper than to Vermeer, to Caspar David Friedrich, or to de Chirico. But Hopper did not necessarily need the human figure to express it. He may not have been a born painter of figures, but human nature was as familiar to him as to any twentieth-century artist. An artist need not depict groups or masses of people, or paint detailed portraits of individuals, in order to prove himself a humane, a humanly interested artist. Hopper dealt sparingly but sensitively with the human figure and its characterization. He showed people in their isolation, but he took this isolation seriously. If most of his figures were small in scale with respect to their setting, never appearing to dominate it, perhaps this reflected the fact that man is no more than a speck in the universe. To Hopper, any other view would have seemed delusory. Every human being remains bound to his or her place in the world, dependent on it, part of a complex system of reciprocal relationships. And in Hopper's pictures everything relates to human beings: the street vistas, building facades, interiors all man-

made, and they exert effects on their makers, including the negative effect of having become separate from, and alien to, them. Hopper shows us an estranged world – and he was able to show it in all its strangeness precisely because he never became a stranger to a sense of the human point of view.

There is a term once coined by Max Beckmann, "transcendental objectivity," that might be applied to Hopper's visual world. Beckmann used it at a time when his art was in a state of upheaval caused by his experiences in the World War I. In 1917, in a catalogue introduction for a show at the I.B. Neumann Gallery, Berlin, Beckmann described the aim of his work as achieving an "objectivity of inner visions." In 1918, writing in his famous *Confession*, he spoke of "transcendental objectivity" as the principle on which his art was based. Objectivity was the bond that held vision and reality together; transcendental objec-

tivity implied the metaphysical quality that suffuses all physical appearance.

In a similar sense, Hopper was concerned during the decade of transition, when he attempted to go beyond his Paris experience and find his way back to his American roots, to achieve "objectivity" (though he did not use this precise term). Doubtless the concept of objectivity had a different accent with Hopper than with Beckmann. Beckmann explored the visible world for the emblematic detail – or combination of such details – in which to embody his "inner vision." But certainly in his case the inner vision came first. With Hopper, in contrast, an experience of external reality took priority. From the time he reached artistic maturity in the 1920s, he was on a constant search, especially in New York City, for motifs that struck a chord in him, triggered intense emotion, awoke an urge to bring them to life on canvas. Perhaps Hopper initially had only a vague notion of what type of motif he sought. Or, having already formed a general visual idea, he may have looked for a real motif to correspond – what Hopper called the "visual fact." Once found, this fact could be tried and tested for the potential it contained. It need not be spectacular – only authentic. Once Hopper had decided on a motif, he began to transform it, to combine it with different settings or with details gleaned from other motifs, to pare it down to essentials – sometimes even losing his grip on it in the process – until he had arrived at a configuration that came closest to expressing his inner emotions and sensations.

Objectivity – if not "transcendental objectivity" – might stand as a leitmotif for Edward Hopper's search for an imagery truly and inimitably his own.

The pursuit of objectivity entailed, first of all, a greater degree of discipline in the painting process. Apparently, Hopper found this very difficult, as if he was reluctant to give up what he had achieved in Paris. He knew this style contained qualities derived from the modern movement, but that they were perhaps no longer relevant to the scene before him. Canvases such as *Road in Maine* and *The Dories, Ogunquit* (illus. pp. 33, 32), both done in 1914, reflect the depth of Hopper's dilemma. Why not use the fluent impressionist brushwork derived from Degas and Monet, or the careful touch of a Cézanne, to embed a road organically in the landscape, or to suggest the white fishing boats and distant houses on the shore of Ogunquit Bay? Why curb the

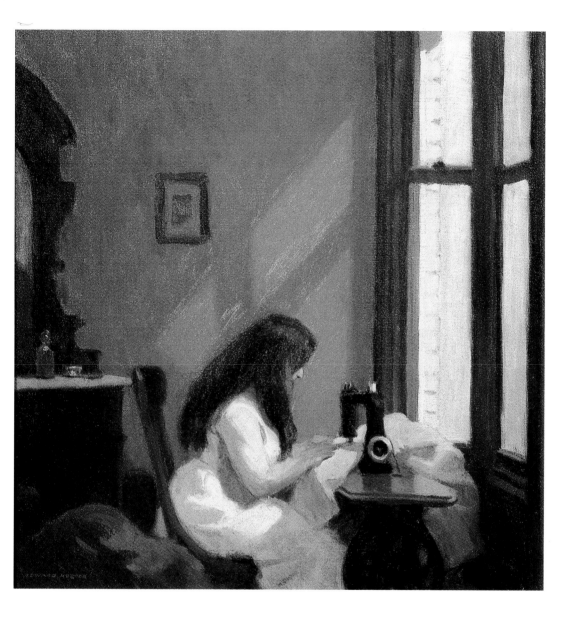

*Girl at Sewing
Machine*
ca. 1921

autonomous brushstroke that had served him so well? I think
these pictures reflect the doubts that must have plagued
Hopper, attempting at the age of thirty to find a new formu-
lation of the American quality. These doubts are still evident
in the Monhegan Island landscapes and seascapes of 1916 to
1919. Indicatively, it was not in landscape that Hopper would
first achieve true originality, but in the portrayals of certain
architectural subjects and compositions with figures in
a typical American ambience: *Small Town Station*, 1918-20
(illus. p. 45), *New York Interior*, and *Girl at Sewing Machine*
(illus. p. 47), both of about 1921, and *New York Restaurant*,
about 1922.

Architecture and interiors, as Hopper understood them,
demanded greater limitations on painterly verve than landscape
subjects. It was the only way to underscore their special, objec-
tive character. Also, a balance had to be achieved between motif
and composition in each individual case. A comparison between
the Maine landscapes of 1914 and thereafter, and paintings such
as *Small Town Station* and *New York Restaurant* is instructive.
In the latter the color range, formerly based on strong contrasts,
has been reduced to only a few values, and the brushstokes have
become shorter, more concise, more anonymous, while again
taking on a descriptive function.

René Magritte in 1923 came across a reproduction of de
Chirico's *Chant d'amour*, 1914. It was a discovery, as he never
tired of repeating, that revealed to him in a flash what he must
paint, and that this What was of prime importance to the art he
envisaged. The What, by calling for the sole outward appearance
that conformed with its nature, would automatically determine
the How of style. To render his calculated images of a self-con-
tradictory and enigmatic world, Magritte accordingly developed
a dry, documentary style that has often been compared to
police reports or to detective stories à la Simenon, an idiom
artful enough to conceal its own unobtrusive coherence. The
unobtrusive, even apparently unstudied character of this style
lent Magritte's disturbing pictorial events a presence that could
have been invoked in no other way.

The parallel between Magritte and Simenon would corre-
spond, in Hopper's case, with an evident affinity between his
style and Hemingway's, for both shared the strategy of paring
down and cutting out. Thanks in part to the influence of Ezra

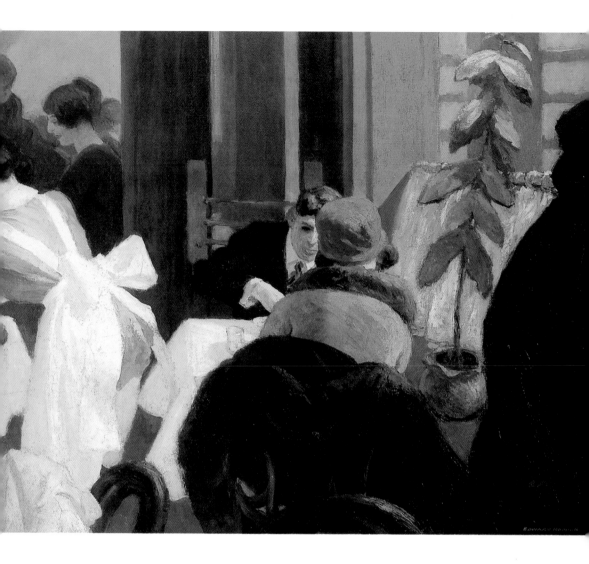

New York Restaurant
ca. 1922

Office at Night

1940

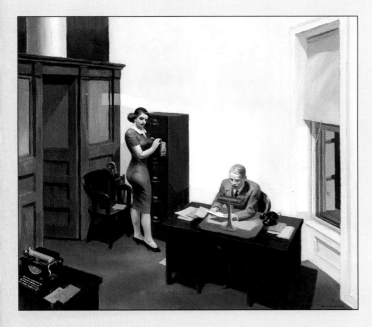

"The picture was probably first suggested," Hopper wrote in 1948 to Norman A. Geske, "by many rides on the 'L' train in New York City after dark and glimpses of office interiors that were so fleeting as to leave fresh and vivid impressions on my mind. My aim was to try to give the sense of an isolated and lonely office interior rather high in the air, with the office furniture which has a very definite meaning for me" (quoted in Robert Hobbs, *Edward Hopper*, New York, 1987, p. 16).

But even more important to Hopper than the furniture was the illumination of the room. He described it as coming from three sources – indirect lighting from above, the desk lamp, and the light coming through the window. The natural light falling on the back wall, he said, represented a difficult problem, because it demanded almost a white-on-white monochromy, and the bright reflection on the upper corner of the filing cabinet was hard to reconcile with the girl's figure.

Although the room is brightly lit, we sense that something strange is going on. Apart from the relationship between the two figures, the suspenseful mood arises from the circumstance that they are apparently poring over confidential material at this late hour, looking for a certain document that has yet to turn up. A sheet of paper has fallen to the floor next to the desk. The man and woman are silent; unspoken trust is essential to their job. In fact, as a surviving preliminary drawing for the painting indicates, it was originally to be called *Confidentially Yours, Room 1005*.

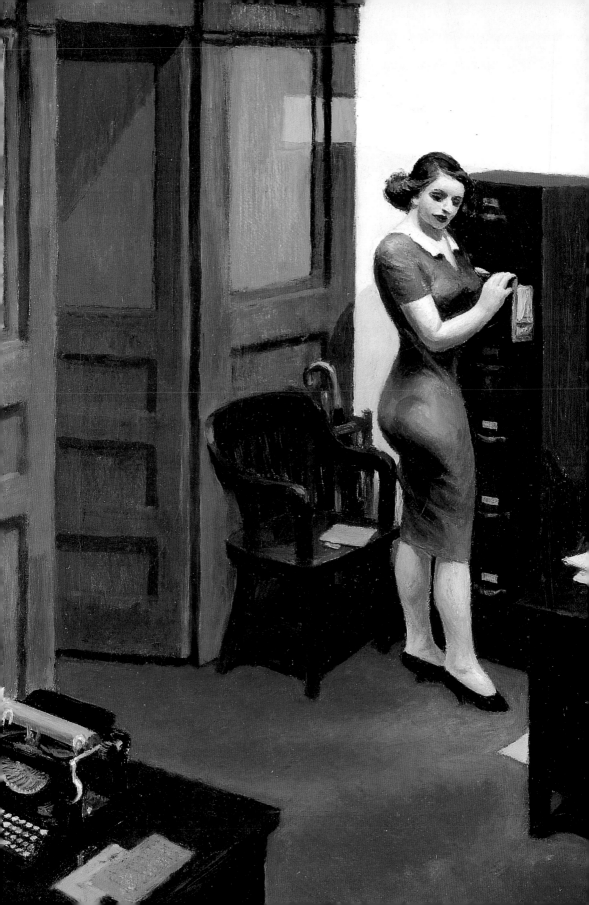

Pound, Hemingway began to develop his personal prose idiom after the World War I, setting out to eliminate precious words in favor of the *mot juste*, and to write short, laconic sentences almost devoid of adjectives.

The painting style Hopper worked out in the early 1920s was not fundamentally different from that of Magritte (who, incidentally, initially made his living as an illustrator and commercial artist). Nothing could be more foreign to this type of idiom than bravura brushwork. Like Magritte, Hopper strove above all to achieve an internal consistency of composition and homogeneity of pictorial form. Only in his landscapes did Hopper continue, into the 1930s, to permit himself the freedom of pulling forms together into expansive units, and of letting the brushstroke stand as an autonomous pictorial element in certain passages.

It is interesting to compare Magritte's *Realm of Lights*, 1954 – one of seventeen versions of the subject he painted – with Hopper's *House at Dusk*, 1935. Apart from the fact that Hopper's picture seems more eerie, because more real, than Magritte's heightened reality, the comparison shows that the effect of such motifs depends largely on a painting technique oriented towards photographic precision. Yet despite a renunciation of sumptuous brushwork, the technique can still evince great finesse in paint handling, as Hopper's painting indicates even more than Magritte's.

In discussing the themes of Hopper's painting, we would do well to inquire first into the subjects it excludes. Knowing what an artist did not choose to depict can say at least as much about him as his favored themes.

Hopper painted many views of New York City, but none of a skyscraper. There is an anecdote related by Alfred H. Barr, Jr., who mounted Hopper's first retrospective at the Museum of Modern Art. Hopper and an artist friend were walking down the street when his friend suddenly stopped and exclaimed, "Look! What a wonderful composition those skyscrapers make, what light, what massing, look at them, Hopper!" But Hopper wasn't interested. "Anything will make a good composition," he said, and walked on. Skyscrapers entered Hopper's scenes by allusion at most – mere slices at the edge of a canvas, never as the central motif. In fact, Hopper may have been the only New York painter of the day not to depict skyscrapers.

ALEX COLVILLE
Truckstop
1966

RENÉ MAGRITTE
Realm of Lights
1954

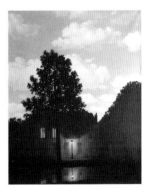

House at Dusk
1935

Other, comparable motifs he avoided were freeways, factories, machinery, industrial plants. Yet Hopper did make frequent, if oblique, references to the industrial, technological age in which we live. It is only that his renderings of everyday life in America of the period exclude everything that has come to be associated with the American cliché. Nor do they show any temptation on his part to celebrate the affluent society.

The people Hopper depicted all belong to the white middle class. We search his pictures in vain for other ethnic groups, not to mention signs of racial or social tension, or of the differences between rich and poor. Hopper's people are not involved in protests or strikes, demonstrations or meetings. They appear to accept their fate passively. The world they live in is strangely

static, the streets largely empty of passersby, hardly a car or truck on the road. No tourist, no stranger has strayed into this silent world. All the windows are closed, and no movement is detectable behind them. It seems to be perpetually Sunday, the city abandoned (or asleep), and for the old man sitting in his shirtsleeves on the sidewalk in *Sunday*, 1926, this Sunday emptiness is apparently even harder to bear than the weekday vacuum, even more meaningless, more of a dead end. This is a world without a future. And perhaps the oddest thing of all – it includes no children. Hopper never portrayed a child. His is a world of adults condemned to extinction, and conscious of the fact.

Hopper's figures are introverted people who communicate very little with one another despite the enormous psychological tension under which many of them evidently stand. They have difficulty in expressing themselves, in overcoming their inhibitions. The significance of this may be gauged by comparing Hopper's figures with those of Edvard Munch. Munch, too, depicted people who were tormented by mental conflicts, but at least they were sometimes able to unburden themselves in a scream (see illus. p. 58). Hopper's people lack any such outlet.

Hopper was apparently averse to depicting extreme situations in life. There are no accidents, no sickness and death in his pictures, no reference to injury or physical disablement. Yet subliminally sickness and death do seem to be present, for we find ourselves asking how often his figures contemplate such things. And since their main occupation is waiting, we might well ask whether, apart from the hopes they still cherish, death might not be one of the things they are waiting for when they sit down in the evening sun (*People in the Sun*, 1960; illus. p. 104).

Hopper depicts people in places where their daily lives are played out: offices, restaurants, movie theaters, trains, hotels. And he makes it perfectly clear that all of them belong to the working world, bound by commitments and obligations, carrying out an occupation that has worn them to its mold. They are office employees, small businesspeople, tenants, pensioners; they work as waitresses or waiters, train conductors, gas station attendants, cleaning ladies, theater ushers, hairdressers, secretaries. They live humble lives, eat at cafeterias or automats or hot dog stands, but they do not go hungry and they still have a roof

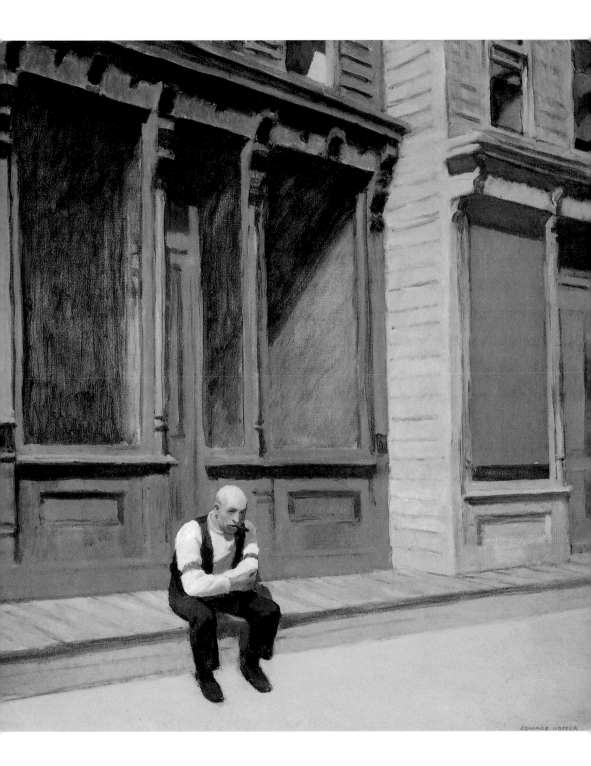

Sunday
1926

Nighthawks

1942

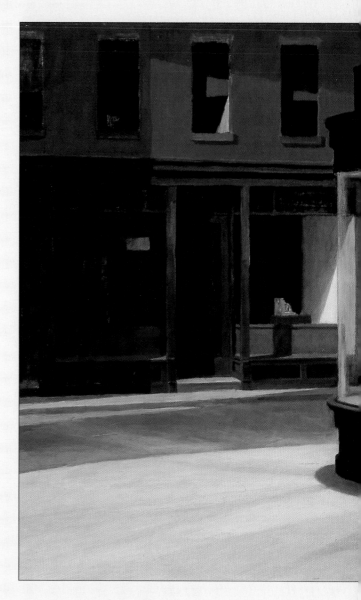

Nighthawks is among the few pictures about which the taciturn painter provided background information. Saying that the scene represented his idea of a street by night, he added: "It was suggested by a restaurant on Greenwich Avenue where two streets meet. I simplified the scene a great deal and made the restaurant bigger. Unconsciously, probably, I was painting the loneliness of a large city" (quoted in Robert Hobbs, *Edward Hopper*, New York, 1987, p. 129).

Critics have compared the atmosphere of *Nighthawks* with some of Hemingway's short stories, which Hopper loved. When in March 1927 he discovered "The Killers" in *Scribner's*, for which he then still occasionally worked as an illustrator, Hopper wrote a letter to the editor. It was refreshing to find such an honest piece in an American magazine, he said, after wading through the saccharine mush of which American literature largely consisted. The story made no concessions to popular taste, divagated

not a bit from the truth, and had no spurious denouement at the end, Hopper wrote.

The couple at the counter have little to say to each other. The man with the hawk's face calls up associations with the *films noir* of the period, especially with Humphrey Bogart in *The*

Maltese Falcon – based on a story by Dashiell Hammett titled for another bird of prey. His hat pulled low over his eyes in the accepted detective style, the man rests his right hand on the counter, holding a cigarette. His fingertips seemingly inadvertantly touch the woman's

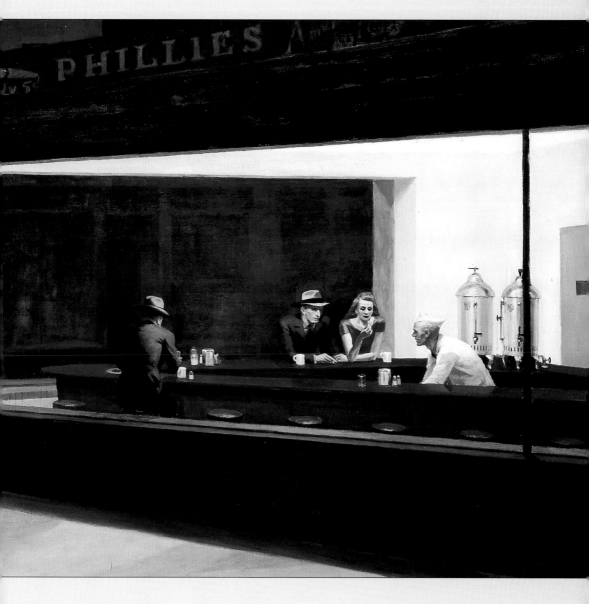

hand. Meanwhile she inspects her fingernails – or is she holding a slip of paper, perhaps with a telephone number on it, which she is about to discard?

The barkeeper – or maybe just a combined counterman and dishwasher – seems to have just made some offhand remark of the kind countermen make, such as "Been a long day today," or "Out late tonight, huh?" – a remark that needs no reply. Another man is seated at the end of the counter, weighing his glass in his hand – Hopper's "silent witness."

What happens from this point on? It's anybody's guess. In Hopper's pictures, as in Hemingway's stories, there is rarely a denouement or resolution.

over their heads. They are found working in their offices late into the night, or sitting in a diner, weary and lost in thought, trying in vain to recuperate. They go to the movies or theater, hoping to forget their jobs for a minute, but cannot seem to manage it. Wherever they go, even on vacation, their employees' cares follow. Not even the lawyers, doctors, managers, or salesmen we see attending a play or gathering in a hotel lobby seem entirely free from such pressures. Hopper's view of human existence shows it in all its paucity – and yet even so, it retains a modicum of dignity.

When Hopper paints a house, a balcony, or an interior, he leaves no doubt as to the time of day. We see morning sunlight slanting through a curtain, or the noontime glare, late afternoon shadows, approaching dusk, or night, a tiny corner of a night in the big city, illuminated by electric lamps, spotlights, neon signs. In every picture we know precisely what time of day or night it is, and at the same time we sense that time is standing still, and that nothing will change. We know that for the person standing at that window or seated at that table, this is the one, inescapable reality, at once representing the universe and a tiny slice of it.

Hopper gives us clues as to the nature of this existence, a thousand details presented with the utmost clarity. And yet we sense that, ultimately, we can know absolutely nothing about it. The only thing we can be certain of is our own ignorance.

Hopper's pictures form a grand continuum. They belong together, each to the next. Each depicts a small section of the world, a brief moment in life. But every picture is suffused with the memory of others; each is at once unique and related to the rest. They might be compared to links in a chain, if it were not for the fact that the sequence is not irreversible or fixed for all time. This statement may seem to be contradicted by such series as that depicting Cape Cod at different times of day: *Cape Cod Morning*, 1950 (illus. p. 60), *Cape Cod Afternoon*, 1936 (illus. p. 61), *Cape Cod Evening*, 1939 (illus. p. 62), and *Cape Cod Sunset*, 1934 (illus. p. 63). As the dates indicate, these paintings were obviously not conceived as a cycle in the narrower sense. Yet they do belong together, forming a greater whole. Interestingly, Hopper painted the morning picture last. Tempted to the window by the morning sun, a woman looks out, narrowing her eyes against the bright light. It is a moment of boundless expectation. But it has been depicted by a man who

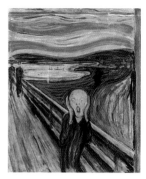

EDVARD MUNCH
The Scream
1893

knew what afternoon and evening would bring, who knew that expectations this great were bound to be disappointed. With the emptiness and loneliness of the evening picture, which he painted first, Hopper anticipated the ultimate meaning of human existence.

The titles of many paintings consist simply of times of day: *Five A.M.*, ca. 1937 (illus. pp. 64-65) – the entrance to a harbor on the New England coast, the gently rolling ocean still devoid of boats. *Seven A.M.*, 1948 (illus. pp. 80-81) – a small store at the edge of a wood, still closed at this early hour. *Eleven A.M.*, 1926 (illus. p. 67) – a woman sitting at the window of a hotel room, reluctant to dress and begin the day. *High Noon*, 1949 (illus. p. 73) – a girl emerging from the door of a farmhouse into the voluptuous warmth of the midday sun. The list could be continued with the many pictures representing afternoon and evening, twilight and sundown, all the way to the fleeting glimpse into a stranger's apartment revealed by *Night Windows*, 1928 (illus. p. 66).

The days pass without anything particular occurring. The hours drag on and on. Some people spend the morning in a living room or a hotel. Others remain at their desk until noon, then go out to lunch at a snack bar or Chinese restaurant. They return to the office and work late into the night, endlessly discussing their business problems: *Conference at Night*, 1949 (illus. pp. 68-69). Or they might go to see a play or film: *New York Movie*, 1939 (illus. pp. 42-43). If sleep will not come, there is always an all-night restaurant: *Nighthawks*, 1942 (illus. pp. 56-57). Then Sunday comes, with abandoned streets and closed stores along Seventh Avenue: *Early Sunday Morning*, 1930 (illus. pp. 12-13).

Hopper tells stories that have nothing anecdotal about them, that are reduced to a single, isolated situation. But, actually, he does not tell stories at all – he depicts life, relates history. Yet it is a history in which before and after seem interchangeable. Everything belongs to a cycle, passes only to return. What Hopper describes is the "heroism of modern life" to which Baudelaire referred, Nietzsche's eternal return of the same. But again, Hopper told no stories about things or people – he simply showed them.

One might go further and say that he staged dramas. An admirer of Ibsen who had read or seen performances of all the

Cape Cod Morning
1950

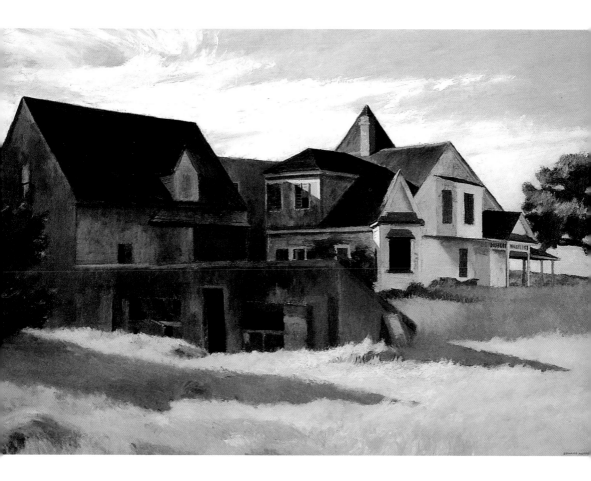

Cape Cod Afternoon
1936

Cape Cod Evening
1939

CASPAR DAVID FRIEDRICH
Morning
ca. 1820

CASPAR DAVID FRIEDRICH
Noon
ca. 1820

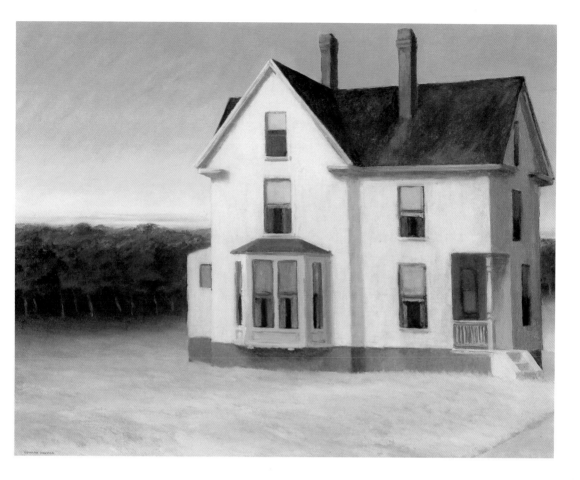

Cape Cod Sunset
1934

CASPAR DAVID FRIEDRICH
Afternoon
ca. 1820

CASPAR DAVID FRIEDRICH
Evening
ca. 1820

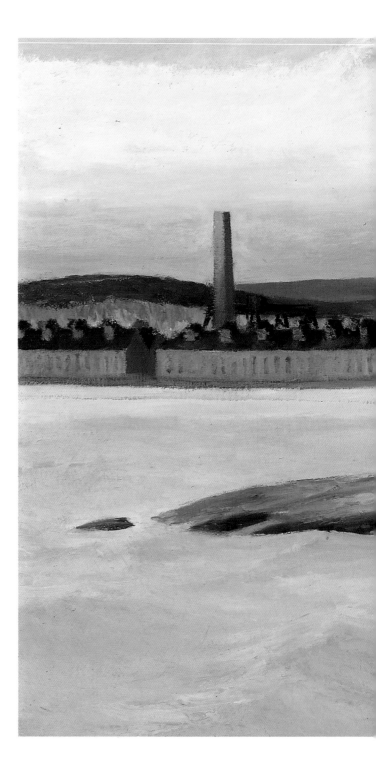

Five A.M.
ca. 1937

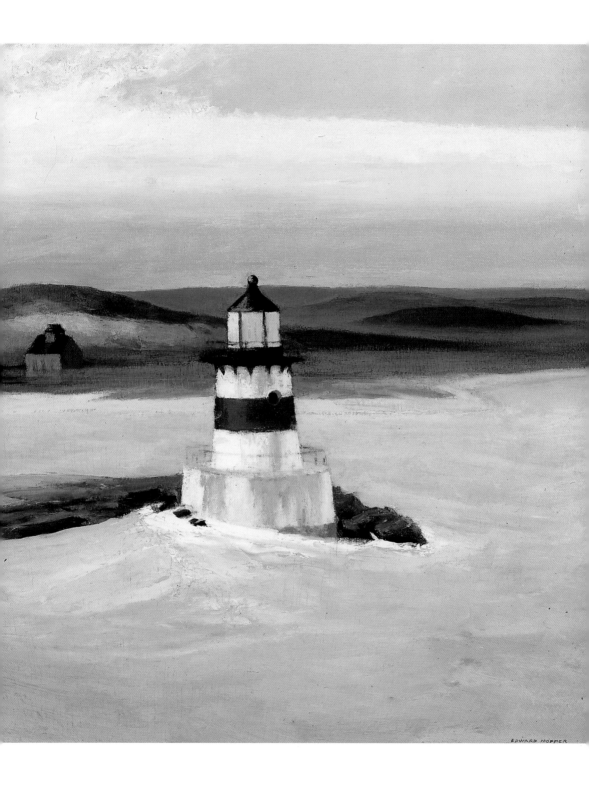

Night Windows
1928

Eleven A.M.
1926

American playwrights from Eugene O'Neill to Tennessee Williams, a passionate theater and moviegoer, Hopper had a fine sense for the latent drama of mundane scenes. In his paintings, he played the role of invisible director, shifting the backdrops, coaching the cast until the scene was perfect. He determined the lighting, placed the characters, added the few, absolutely necessary props, always with an eye to achieving the simplest possible arrangement and the greatest possible suspense. It was Hopper's finest accomplishment to have reduced the geometry of the pictorial stage so radically and constructed it so precisely that each detail relates to all the rest, engendering a constellation in which every visual element seems charged with allusions.

Hopper's wife Jo, who originally wanted to become an actress, served him as a model, posing as a secretary, a theater usher, a passenger on a train, or a receptionist in a hotel, all of which roles she filled with her presence. Painting her in his New York studio, Hopper conducted his own little theater of the world. She and other people he had observed appear in a hundred different costumes. But they always appear in the same play – a play without a plot, in which nothing occurs, nothing develops.

The way in which Hopper presents this eventless play has something indiscreet, voyeuristic about it. He stands just outside the scene, unnoticed, as if waiting to catch the characters at moments in which they would least wish to be observed. He opens an invisible door and enters the room unannounced. By inviting us to accompany him and surprise his figures in their private realm, alone with their most intimate thoughts and feelings, he catches us out as well.

Sometimes we flinch, and think to ourselves that these are scenes not meant for others' eyes, pictures that perhaps should not have been painted at all. Through a window or over the footlights or through a glazed wall we gaze inquisitively or ashamedly, sympathetically or indifferently into the intimate life of someone who might be ourself. We have the sense of being interlopers, witnesses to depths of the human soul that should not be revealed. No one wishes to be stripped naked like this.

Is it improper, even illicit to do so? Hopper walks a thin line, and he does it with perfect aplomb. In face of his pictures,

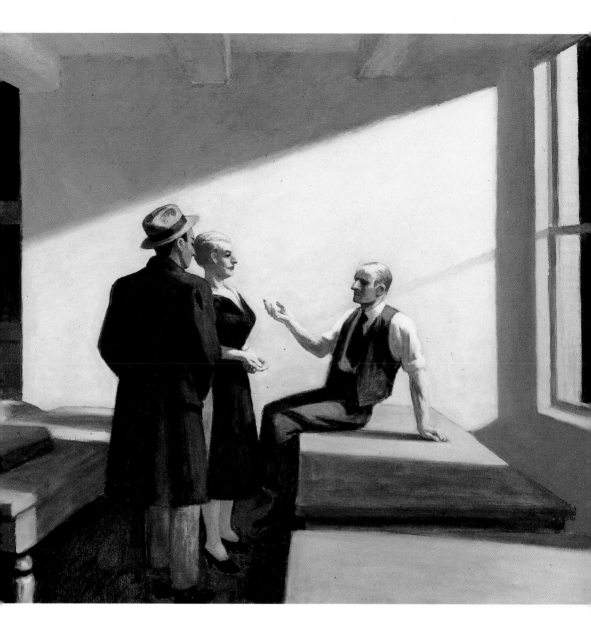

Conference at Night
1949

Hotel Lobby

1943

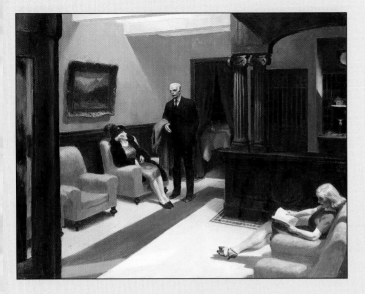

Hopper often shows us people on the move – in a train or on the platform, at restaurants or gas stations, hotels or motels. In *Hotel Lobby* he combines the motif of travel with that of waiting. We do not know exactly what the three people in the lobby are waiting for (there is also a fourth person, almost completely hidden behind the reception desk – Hopper's "silent witness"). An elderly couple ready to go out – she in coat and hat, he with his coat over his arm – are perhaps waiting for a taxi, or for a friend to pick them up to go to a dinner party or to take them to the theater. Meanwhile, a young woman sits alone, reading a magazine. She seems to have plenty of time on her hands, and the purpose of her wait is even more obscure than the couple's destination.

How carefully Hopper arranged such compositions is shown by the many preliminary drawings for *Hotel Lobby*. Again and again he varied the cast of characters, putting a young man in the girl's place at the right, or sketching an additional figure in the chair next to the lady on the left. He also varied the figures' positions and poses. Initially, the couple in evening dress had eye contact with each other, but Hopper decided to let the man look away. He gazes with a mixture of boredom and irritation towards the entrance, waiting for the sign that will finally relieve him and his escort from their ennervating wait.

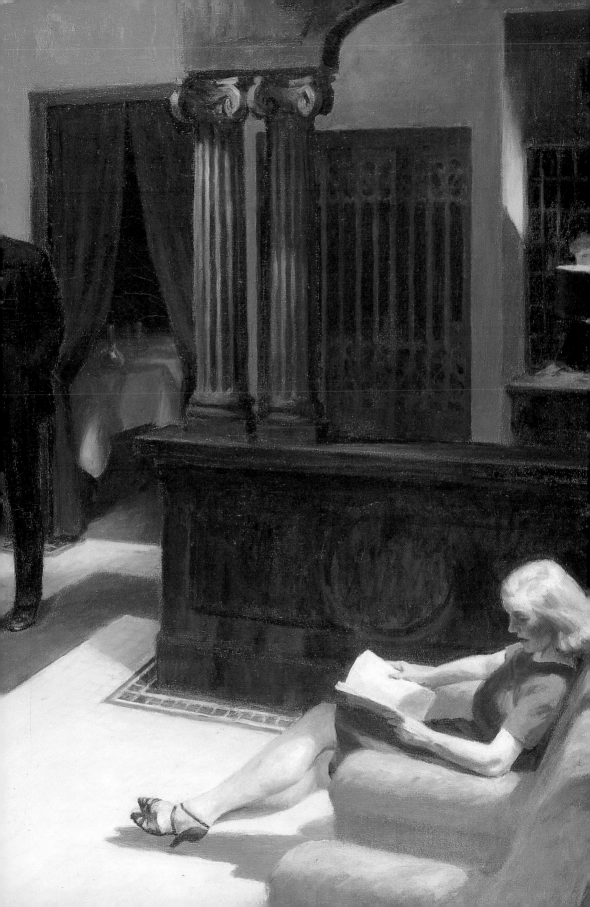

we think we ought to lower our eyes, and nevertheless gaze on, fascinated. We intrude upon someone's intimate sphere, and ultimately feel no embarrassment. We look into the depths of banality and in the end find it quite normal.

In a *Time* cover story published in the mid 1950s, Hopper was dubbed "The Silent Witness." He is present in the court-room of life, but opts not to testify. Yet he cannot make us forget that he has seen something crucial. This is the point at which the dialectic of Hopper's paintings takes hold. They reveal and con-ceal, awake expectations and disappoint them. No other artist has demonstrated more clearly than Hopper that the most mundane human situations can also be the most deceptive and the most revealing. Hardly any other has said so much about the lives of people in his time than this silent witness, or done so with so much respect, decency, and perhaps we could even say, with so much diffidence. If the two, apparently irreconcilable traits of sophistication and diffidence have ever occurred together, it is in Edward Hopper's art.

We know that in his years of maturity, painting became increasingly difficult for Hopper, costing him more and more effort as time went on. Though he never wanted to do anything

but paint, he continually had to force himself to begin the next canvas. It took a long time until he had found a motif worth representing, more time to determine the suitable format, decide on a color range, establish proportions, and arrange the lighting. Once he had actually begun painting, Hopper sometimes felt that he was losing his grip on the original idea, that the picture was going in a way he had not intended. The result, he said, was often quite unlike what he had had in mind. The watercolors he began doing in 1923 were spontaneous studies, executed outdoors, often on trips. The oils, in contrast, were almost always done in the studio (*Lighthouse Hill*, 1927, and *Lighthouse at*

High Noon
1949

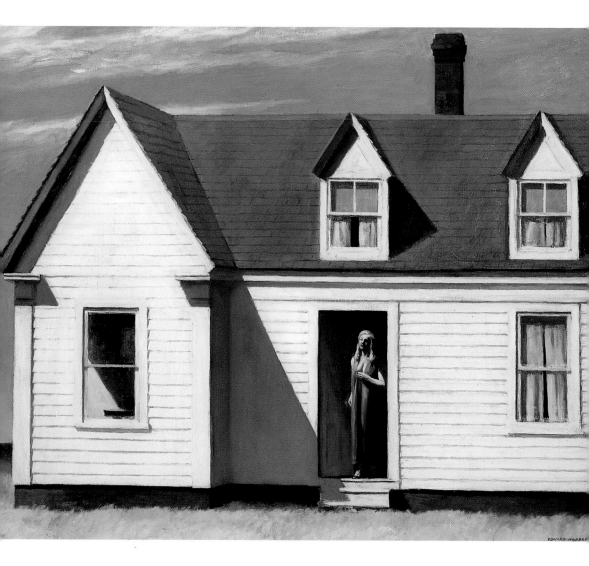

Two Lights, 1929, were among the last open-air landscapes he painted). Fleeting impressions gathered on his walks through Greenwich Village or from a car on the long since demolished New York El were distilled in the studio into strong, compelling designs. The many sketches Hopper would devote to a single motif document the long and painstaking process of producing a painting.

Apart from their actual subjects, Hopper's pictures also address the issue of perception. They include the viewer's eye, despite the fact that the figures appear entirely self-absorbed and unconscious of being observed. Hopper suggests that the figures we see do not realize they are seen. We remain outside their lives, looking in; for them we are not there, non-existent. At the same time, they perceive things that remain hidden to us, beyond our field of view. This is especially clear in the compositions with a woman at a window. Often she gazes into a space that is either concealed from the viewer or outside the picture entirely. Or is she looking into nothingness? Might she be so preoccupied with herself that she is oblivious of everything going on around her?

Many of Hopper's paintings contain a covert eroticism. It is not explicit, merely hinted in numbers of tiny details. This is especially true in the depictions of women, surprised in dishabille in their hotel room or apartment. Apparently awakened by the sun, they gaze musingly out the window as if wondering whether this might be the first day in a new life: *Morning in a City,* 1944, *Morning Sun,* 1952 (illus. p. 79), *City Sunlight,* 1954, *A Woman in the Sun,* 1961 (illus. p. 77). The erotic suspense in these scenes derives from the absence of a partner, which tempts the viewer – male certainly, female perhaps – to assume the role and enter a stranger's story. Hopper's women are vulnerable, marked by disappointment, in need of protection. Yet they still seem to harbor hopes and expectations. We have the impression that there is something undefined, perhaps unnamable, but at least beyond our comprehension, to which they wish to surrender themselves. A woman turns to the rising sun, opens herself to the ultimate source of light – reminding us that nature extends even into the most desolate corners of the city.

Woman in the Sun is a bit closer to nature than the big-city woman. In fact, she has reached the borderline. Hopper has put her in a situation beyond which she cannot go. She has let the

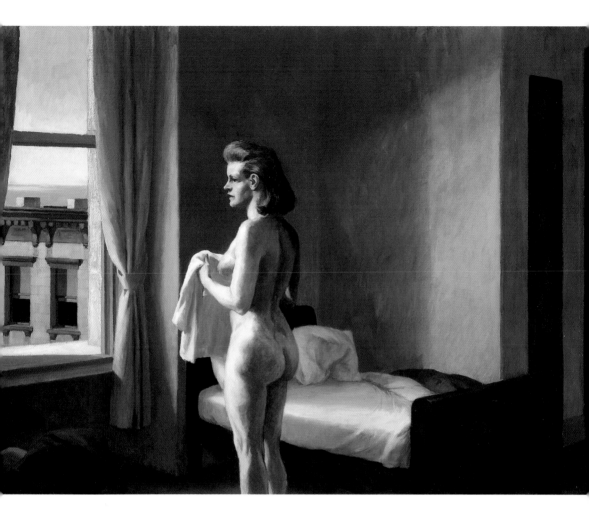

Morning in a City
1944

sun take possession of her. She holds a cigarette, but has forgotten to light it. She has forgotten herself.

It is this sunlight in Hopper's pictures that places the figures so tangibly before us, and that simultaneously removes them to a distance, lends them an aura of the ineffable. Hopper's rendering of the figure at once suggests proximity and demonstrates the unbridgeable gap between life and art. Realizing that this gap exists may be painful, but it does free us as viewers from the role of voyeur and permit us to assume the artist's role – that of silent witness.

So it is not we who lower our eyes after all, it is the figures we observe who do. If they are not fascinated by the slanting sunlight, they keep their eyes down. And it is this lowered gaze that makes Hopper's figures seem so introspective, as if looking into themselves. They pursue their own thoughts or dreams, which sometimes lead them far from the here and now. The *Girl at Sewing Machine*, ca. 1921 (illus. p. 47), the man in shirtsleeves sitting on the sidewalk in front of a closed store in *Sunday*, 1926 (illus. p. 55). The woman sitting on the bed in a hotel room, holding a piece of paper – a timetable, or a farewell letter? Must she leave again, before even having had time to unpack her bags? Or has something come to an end, and her trip been in vain? She seems to be studying the sheet for the hundredth time, as if unable to grasp its meaning. Her face is in shadow, her thoughts stray: *Hotel Room*, 1931 (illus. p. 78).

Or the girl in a restaurant, seated in front of a dark window in which rows of lamps are reflected, gazing at her coffee cup as if it were the last thing in the world she could hold on to: *Automat*, 1927 (illus. p. 83). Or the usher in an almost empty cinema, who has probably seen the movie countless times and prefers her own dreams: *New York Movie*, 1939 (illus. pp. 42-43). Or the gas station attendant who, apparently expecting no more customers today, turns off the pumps: *Gas*, 1940 (illus. pp. 30-31). Or the woman at her living room window in the city, who seems oblivious of the slanting evening light: *Room in Brooklyn*, 1932 (illus. p. 82).

Hopper may show us only the surface of things, but he means what is beneath it. As the dark expanse of the automat window indicates, what is outside is only the inside reflected. And what holds for his interiors applies by analogy to his figures and their inner lives: their thoughts and dreams are no more

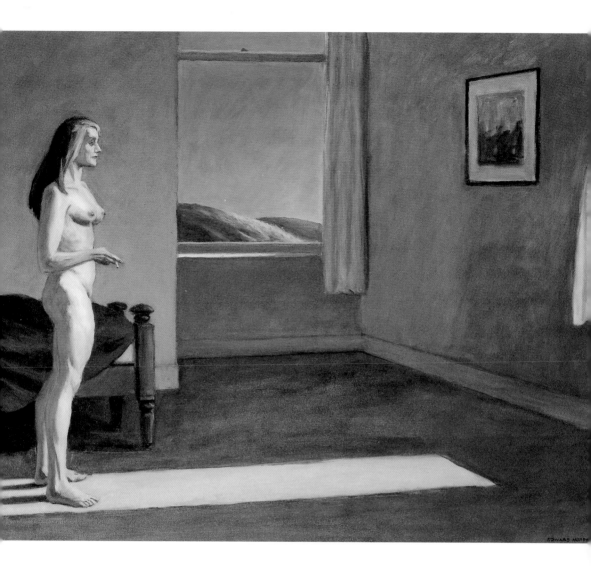

A Woman in the Sun
1961

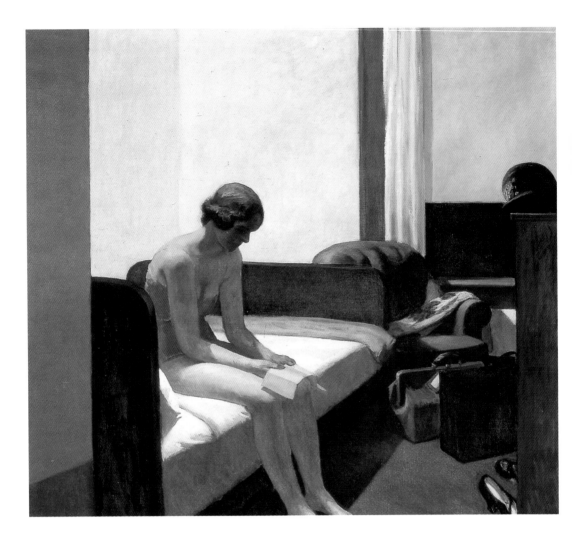

Hotel Room
1931

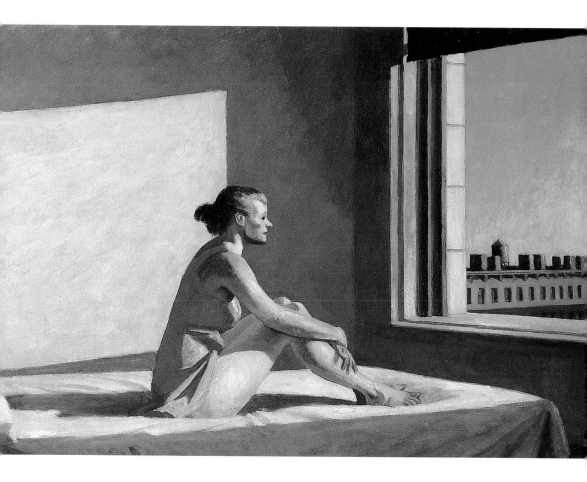

Morning Sun
1952

Seven A.M.

1948

It is seven in the morning, and the store has yet to open. But perhaps it never will, having been abandoned long ago. There are no goods in the window, only a few plain, insignificant things: three soda water bottles and two prints or photographs mounted on card, perhaps as decoration. The clock on the left wall, the most interesting feature in the display, shows the time. In the interior of the store, empty shelves and a cash register are visible. What is, or was, sold here? What is Hopper telling us?

Jo Hopper wondered, too, and in notes that supplemented her husband's journals – a four-teen-volume studio diary containing sketches from memory of all his oils – she surmised the store was a "blind pig" or a speakeasy, a place illegally purveying alcohol during the Prohibition. She also thought she could discern a pool table in the back.

Hopper leaves the question as to the nature of the store's business open. The design of the picture resembles that of *Cape Cod Evening*. In both cases there is a transitionless and slightly eerie juxtaposition of dark woods with light-colored building extending diagonally into the picture, and in both cases the dark zone seems to encroach on and threaten the structure. Of *Cape Cod Evening*, Hopper wrote: "It is no exact transcription of a place, but pieced together from sketches and mental impressions of things in the vicinity. The grove of locust trees was done from sketches of trees nearby. The doorway of the house comes from Orleans about twenty miles from here [South Truro]... and the dry, blowing grass can be seen from my studio window in the late summer or autumn...." (quoted in Lloyd Goodrich, *Edward Hopper*, New York, 1989, p. 129). *Seven A.M.* was very likely composed in a similar way.

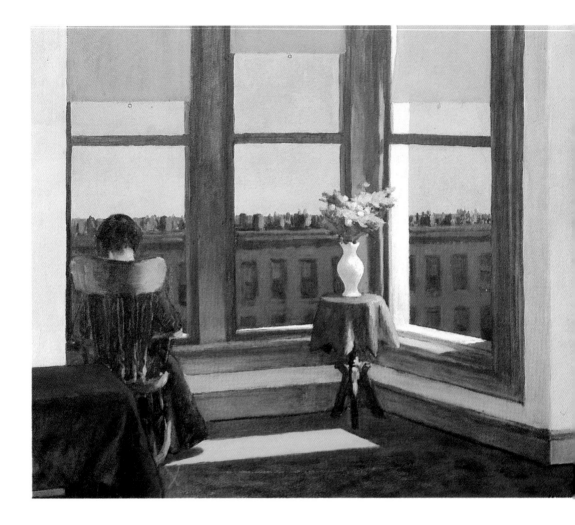

Room in Brooklyn
1932

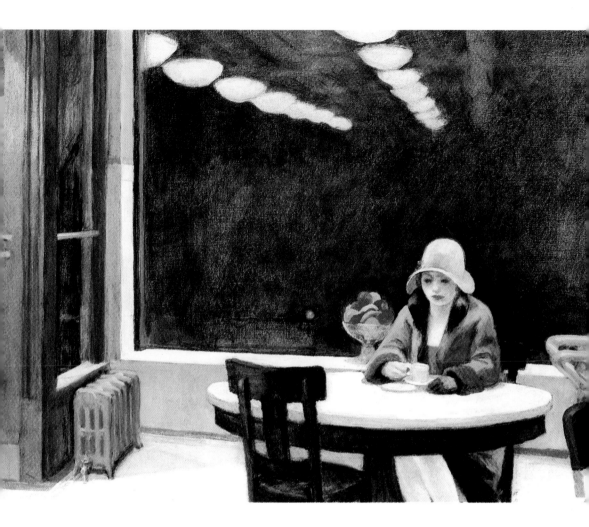

than an equivalent of the external circumstances. They are a precise mirror image – emptiness reflected in emptiness.

Hopper's people give the impression of being people attempting to escape something. They are involved in themselves and cannot seem to get their lives straight. They escape the society of others, and would like to escape themselves. They are not really at home anywhere, neither in a room nor outside, neither at work nor at play, neither alone nor with others. That is why they are on the move. Their home is a train station, a highway restaurant, a gas station, a hotel or motel, a train compartment, a snack bar, a theater foyer, a movie house.

They are going somewhere without being able to arrive. They have personality traits that seem mutually exclusive. They are mobile and restless, yet statically tied to some location from which they will probably never escape. Could that be the reason why they apparently seek out borderline places, sites of transit like stations and motels?

And where does their road lead? It is rare in Hopper's pictures to find a road leading into the distance, and when it does, it is usually as uninviting as the one in *Solitude*, 1944. Generally the road runs parallel to the lower edge of the picture, and its source is as unclear as its destination, as in *Burly Cobb's House, South Truro*, ca. 1930 (illus. p. 34), *Corn Hill*, 1930 (illus. p. 35), *The Camel's Hump*, 1931 (illus. p. 86), *Road and Houses, South Truro*, 1930-33 (illus. p. 87), *October on Cape Cod*, 1946, *Sunlight on Brownstones*, 1956 (illus. p. 89), or *Road and Trees*, 1956. When a road runs diagonally through the picture, it may lose itself in dark woods, as in *Gas*, 1940 (illus. pp. 30-31); shoot off the canvas, as in *Route 6, Eastham*, 1941; or be intersected by an obstacle that seems to cut off the path, as in *Railroad Crossing*, ca. 1922-23 (illus. p. 88).

Being on the move changes the way we perceive our surroundings. In *Western Motel*, 1957 (illus. pp. 92-93), a woman sits beside her packed suitcases as if waiting for someone to pick her up – turning in our direction as if we were that someone. Visible through the picture window behind her are a low range of hills and a higher plateau. These lie in shadow, and have the vague, simplified appearance of mountains glimpsed from a moving car or train. But once we have become used to the fact that they are stationary, we notice that they repeat the shape of the car whose

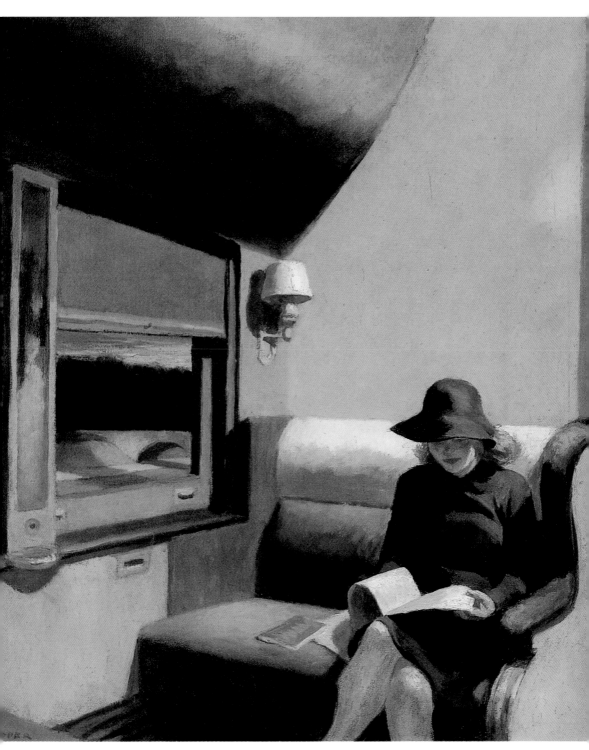

Compartment C, Car 293
1938

The Camel's Hump
1931

Road and Houses,
South Truro
1930-33

Railroad Crossing
1922-23

Sunlight on Brownstones
1956

Sunlight in a Cafeteria

1958

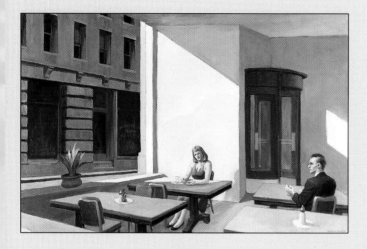

Hopper is a master of subtle allusion. We see a man and woman seated at separate tables in a sunny cafeteria. They are the only customers. What interests the artist is the suspenseful moment before a first tentative contact is made, the mental and emotional forcefield that can arise between two strangers.

In a sense, *Sunlight in a Cafeteria* – as Rolf Günter Renner remarks – represents a reversal of the situation in *Nighthawks*. Instead of a diner with counterman we see a cafeteria with no one to wait on the customers. Instead of a nocturnal scene with fluorescent light, we have bright daylight. Instead of looking into an interior from outside, we are inside looking out. Instead of an apparently prominent big-city corner, we are on a quiet side street. But the most important difference lies in the fact that while the night owls have apparently come to the diner together, the two cafeteria guests are strangers. She sits in full sunlight, he in semi-shadow. He turns towards her, but conceals his interest by looking out of the window. She is unable to show her interest even to this extent, not even attempting to catch his eye as if by accident. She might turn inconspicuously towards him, but hesitates and looks down at her hands. This is not going to work. The harsh shadow-line between man and woman will not be overcome unless one of them takes the initiative.

Watching the mundane scene in the cafeteria with its empty, polished tables, we suspect what will probably happen. The two strangers whose eyes so timidly sought each other will get up and leave without having exchanged a word. It happens a hundred times a day in the big city.

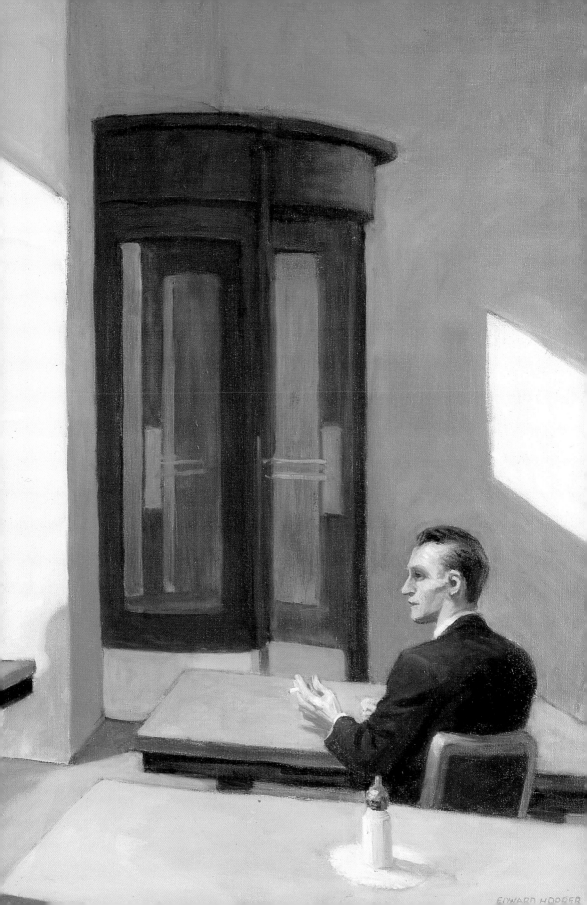

EDWARD HOPPER

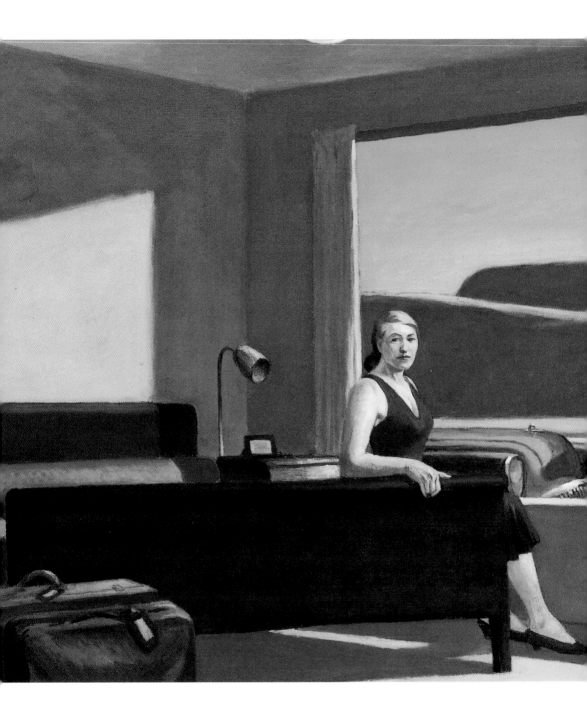

Western Motel
1957

front end is visible in the window behind the figure. And con-
centrating on the car, we suddenly have the giddy feeling that the
hills are in motion.

Even more clearly than Hopper's roads, his railroads suggest
the absence of any particular destination. The tracks never lead
into a landscape, only through and out of it. They almost always
extend across the entire picture, parallel to its lower edge. They
interpose themselves like a barrier between us and the distance,
holding the eye. The tracks divide the picture into two domains,
near and far, as in *House by the Railroad*, 1925 (illus. p. 9), *Railroad
Sunset*, 1929, *Hills, South Truro*, 1930 (illus. p. 96), or *New York,
New Haven and Hartford*, 1931 (illus. p. 97). Only once did
Hopper depict a road with comparable radicality, in the late
work *Road and Trees*, 1962.

The rail embankment may mark a frontier beyond which
the terrain of civilization seems to end, as in *Railroad Crossing*,
ca. 1922-23, or *Railroad Sunset*, 1929. On the other hand, we
sometimes see a house like an outpost in the unknown: *House by
the Railroad*, 1925, or *Dauphinée House*, 1932.

When we compare Hopper's *Railroad Sunset* with a painting
by Frederic Edwin Church, *Twilight in the Wilderness*, 1860, it
becomes clear how greatly America's sense of itself had changed
in a mere three-quarters of a century. The belated Romanticism
of the Hudson River School and Hopper's realism seem literally
worlds apart. Church's painting is suffused with the nineteenth-

FREDERIC EDWIN CHURCH
Twilight in the Wilderness
1860

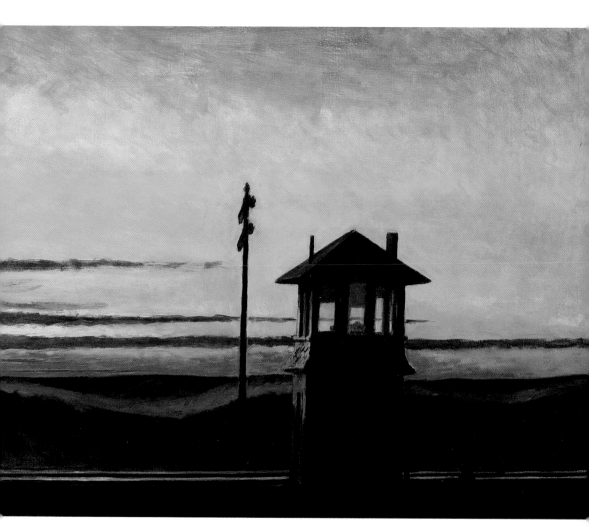

Railroad Sunset
1929

Hills, South Truro
1930

*New York, New Haven
and Hartford*
1931

Second Story Sunlight

1960

The various meanings of Edward Hopper's paintings reveal themselves only within the context of his oeuvre. A case in point is *Second Story Sunlight*, which depicts a seemingly untroubled scene on a balcony in the afternoon sun. The picture is particularly closely related to *Two Puritans* (1945), *Summer Evening* (1947), and *High Noon* (1949). One might even claim that *Second Story Sunlight* represents the quintessence of these three paintings.

Two Puritans is Hopper's ironic title for the portrayal of two narrow housefronts (which, aside from lacking balconies, are almost identical to those in *Second Story Sunlight*). The facades evince Puritan narrow-mindedness and anxiety combined with self-righteousness. These houses are cages: They hold people

captive and govern their lives. In *High Noon* a young woman attempts to escape from this prison. The midday sun entices her forth. As long as ist continues to shine, she is able to dream of unlimited freedom. Evening will return her to her cage.

The third painting, *Summer Evening*, depicts just such an evening, full of destroyed illusions. A young couple's conversation seems to have broken down. Their relationship would appear to have come to an end. Nothing works anymore. They have nothing to say to each other – and if they did, neither would listen. The young woman, scantily clad in a two-piece bathing suit, might be the older sister of the girl in *Second Story Sunlight* who, sitting on the edge of the balcony, wishes to escape the eye of the alert old man next to her. She seems sure

to suffer the same fate as the young woman in *Summer Evening*. Literally and figuratively in a precarious state of equilibrium, she apparently longs for a relationship that would grant her stability. Yet she will no doubt fail, like everybody else. Hopper knows what disappointments lie in store for people. He sees them trying to attract attention and recognizes the futility of such attempts. He knows that the vitality of youth passes, to end in the resignation of old age. That is the way of the world. It appears immutable, to be neither welcomed nor regretted.

Hopper once noted that the girl balanced on the balcony in *Second Story Sunlight* was a "sheep in wolf's clothing." By this he meant that the innocent creature would perhaps like to be mankiller, but is destined to be eaten

up herself after all. The victim would so much prefer to be the culprit. In this, the girl is like anybody else.

Those who believe that the world can be improved, that people can change themselves, will object to Hopper's resignation. He was certainly no advocat of emancipation. He had no ambitions to change the world. Very few good artists ever have.

Hopper's view of his fellow human beings is free of both disdain and sentimentality. He always took pains to appear stoical and not to show pity. Yet he was not able entirely to suppress the sympathy he felt for all phenomena of the visible world – including people. If it had been otherwise, he could not have painted the pictures he did.

century pioneer spirit that responded to the call of nature – and of the land or gold to be had on the Western frontier. This effect is engendered partly by a perspective that draws the viewer's eye into the picture, partly by the twilight mood and setting sun, suggesting an immense, open land without borders – or at least without insuperable ones. Let us follow the sun – that might well have been Church's motto.

Now take Hopper's *Railroad Sunset*. Here there is no path, let alone a road, leading into the distance, nor can the eye discern much in the deep shadow that extends to the horizon. The barrier of the rail embankment and low hills behind seems insuperable. We can trace the horizon and sunset clouds with the eye, but we cannot approach them. They remain at a constant distance. The natural world shuts us out, like the deserted signalman's house. There is nothing left to conquer in the environment, which has removed itself from our grasp. Hopper exposes the infantility of nineteenth-century dreams of subduing nature.

In the rare cases when he depicts rails running into the picture, a sense of threat accompanies them. In *Approaching a City*, 1946, Hopper couches this sense in a compelling visual metaphor: a cavernous tunnel leading into the bowels of the city. It opens out to receive the traveller like a dark maw from which there is no escape.

But there are other situations in which darkness threatens someone on the move. It stretches like an impenetrable wall in front of the woman sitting in a hotel foyer at night, attempting to catch a glimpse of the dark street through the window. Her glance is reflected, and all she can see beyond the black wall are phantoms. Nobody is still out at this hour; the woman waits in vain.

Yet light can be even more merciless than darkness. When you consider the light in Hopper's pictures – cold, bright, often glaring light: sunlight, electric light, fluorescent light, light as if cast by spotlights – you realize that light can indeed be ruthless. George Segal, the American sculptor, once quipped, "When you get to Hopper all of a sudden you have to put on your sunglasses." Hopper's light can be blinding, but it has no warmth. It can awaken the hope of a new life only to disappoint it a moment later – think of the many female figures who bask in the sun, receptive and full of expectation, but who are apparently

Approaching a City
1946

New York Office

1962

Hopper loved to show what is
known in theater parlance as the
"retarded moment." The animation
of urban life is suspended for a
brief moment, haste and unrest
come to a standstill, revealing the
absurdity of the rat race. A secre-
tary behind a big picture window
holds a letter in her hand, appar-
ently lost in thought – until the
telephone ringing on her desk
recalls her to the real world.

Most of Hopper's depictions of
office scenes are interiors, or at
least suggest this point of vantage.
New York Office is an exception.
Here we stand outside looking into
an office, perhaps a bank. Our role
is that of a passerby hurrying along
the sidewalk. But suddenly we are
caught up short. That beautiful ap-
parition in the sun-flooded window
– isn't it Marilyn? No, of course
not, but the resemblance is amaz-
ing.... And musingly we go on our
way.

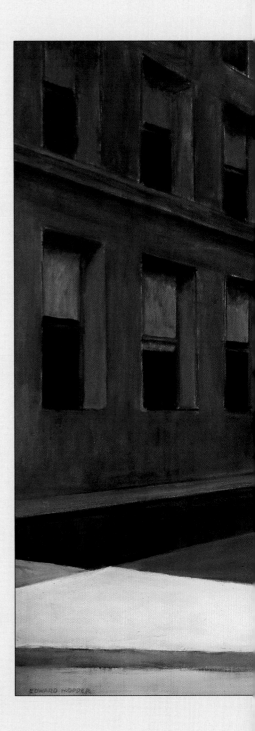

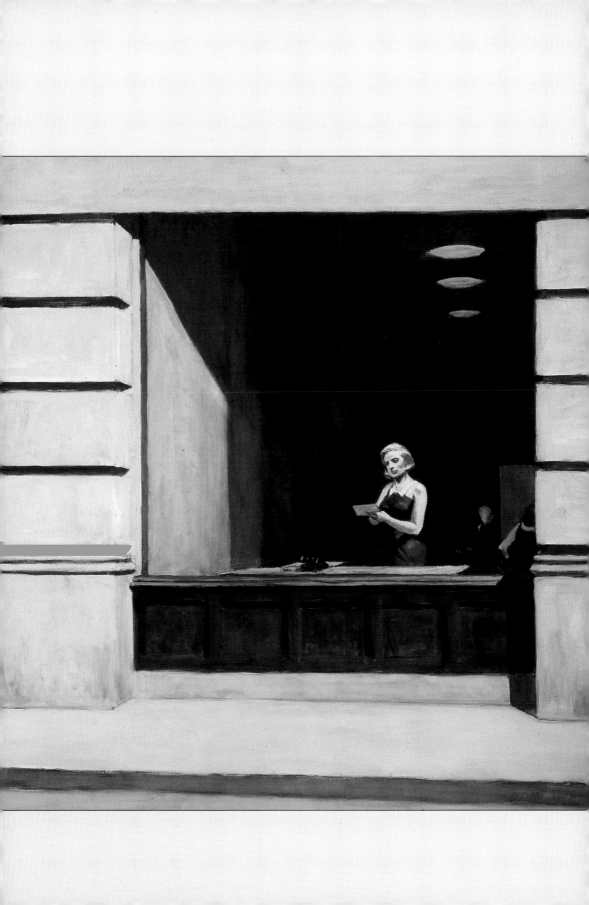

People in the Sun
1960

destined to remain alone. This is a light that isolates people, deepens their loneliness; light that might have been designed for an inquisition.

Hopper's people are continually deceived by it. They seem to worship the sun, letting it tempt them out of their hiding places like moths to a candle flame, as in *High Noon*, 1949 (illus. p. 73), *Cape Cod Morning*, 1950 (illus. p. 60), *South Carolina Morning*, 1955 (illus. p. 106), *Second Story Sunlight*, 1960 (illus. pp. 98-99), or *People in the Sun*, 1960. But it is a flame so cold as to pose no danger of immolation.

People in the Sun are hotel guests who have been tempted out onto the patio to bask in the sun. They seem to take no notice of the scenery around them. Apparently they do not feel warm, for none of them has taken off a jacket or sweater. Perhaps they are even freezing. Wanting to give themselves over to the sun, they have inadvertantly put themselves at its mercy. And the sun reveals all – their inadequacy, the shallowness of their emotional and mental lives. Evidently they had hoped to impress each other with their fashionable attire, but now no one seems to notice or care. Only one man emphasizes his difference from the rest. He has seated himself a little behind, as if in the lee of the row of others, to concentrate on his book. But the cold sunlight holds him in its grip as well.

Rembrandt enfolds his figures in a protective darkness as if in a mantle. His dusky chiaroscuro mercifully hides the things he does not wish to show. Rembrandt's pictures seem to say: what takes place in a person's heart must always remain obscure.

Hopper in a sense removes Rembrandt's people from their comforting shadows and subjects them to the light of Vermeer. Unlike Rembrandt's figures, however, Vermeer's were created for the light – born into a brighter, more rational world, they were more forthright and self-disciplined, and less vulnerable. Hopper's figures, in turn, are as vulnerable as Rembrandt's, but they have been expelled from Rembrandt's paradise, the paradise of the past, to be forever subjected to the harsh light of the present.

One of Hopper's last paintings, done in 1963, is titled *Sun in an Empty Room*. With *A Woman in the Sun*, 1961 (illus. p. 77), a borderline had been reached, beyond which the ambivalence of light and its effects on a human being could not be pushed. The only logical next step was to contemplate light in the

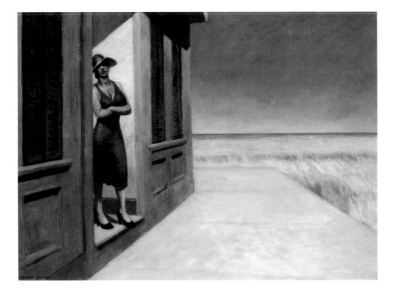

absence of a figure, to invoke an empty room. This is precisely what *Sun in an Empty Room* does – its sole subject is light.
Asked what he intended to express here, Hopper simply replied, "Myself."

Biography

1882	Edward Hopper is born on 22 July, in Nyack, New York
1888-1899	Attends a local private school, then Nyack High School
1899-1900	Training at the Correspondence School of Illustrating, New York City
1900-1906	Studies illustration at the New York School of Art, followed by painting courses with William Merritt Chase, Kenneth Hayes Miller, and Robert Henri. Hopper's fellow students include George Bellows, Guy Pene du Bois, and Rockwell Kent.
1906	Employed as illustrator with C.C. Phillips & Company. In October, makes first trip to Paris.

New York Corner
(Corner Saloon)
1913

1907	Hopper goes during June and July to London, Amsterdam, Haarlem, Berlin, and Brussels. Returns to New York in August, resuming his commercial art work.
1908	Exhibits in New York that March in the "Exhibition of Paintings and Drawings by Contemporary American Artists," organized by Henri's students.
1909	Second trip to Paris, where he stays from March until August, then returns to New York.
1910	Hopper participates in the "Exhibition of Independent Artists," New York, organized by Henri, John Sloan, and Arthur B. Davies. That May, makes third trip to Paris, visiting Madrid and Toledo during his stay. Returns in July to New York, where he continues to work as a commercial artist and illustrator.
1912	Paints during the summer in Gloucester, Massachusetts.
1913	Included in the "Armory Show" with an oil, *Sailing*, of 1911. That autumn Hopper moves into a studio at 3 Washington Square North, where he will live until the end of his life.
1914	Contributes to several group exhibitions. Spends the summer in Ogunquit, Maine.
1915	Begins work in etching. Participates in further group shows. Again summers in Ogunquit.
1916	Eight Hopper caricatures are published in the magazine *Arts and Decoration*. Paints during the summer on Monhegan Island, Maine, where he will return each summer through 1919.
1917-1918	Oils and etchings shown in group exhibitions. Wins first prize in a poster competition with his design, *Smash the Hun*.
1920	Hopper's first one-man show, at the Whitney Studio Club, New York.

Self-Portrait
1925–30

Jo Painting
1936

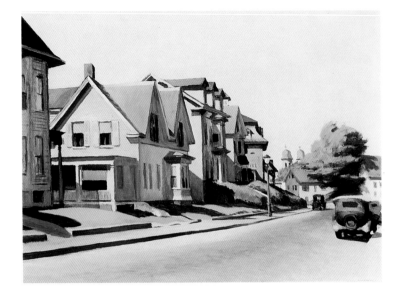

1921-1922	Participates in group shows at the Whitney Studio Club.
1923	Takes an evening course in drawing from the nude at the Whitney Studio Club. At an Art Institute of Chicago exhibition, receives the Logan Prize for an etching. Makes last etchings (though in 1928 he would do two, definitively final plates). Begins working in watercolor. Spends the summer in Gloucester, Massachusetts. Exhibits watercolors in an international group show at the Brooklyn Museum, which purchases *The Mansard Roof.*
1924	On 9 July, Hopper marries Josephine Verstille Nivison, a fellow artist. Summers in Gloucester. Shows his watercolors at the Frank K.M. Rehn Gallery, New York. The show sells out; Rehn will remain Hopper's dealer throughout his life.
1925	Gives up his commercial work (final illustrations will be published in 1927, in *Scribner's* magazine). Spends June to September travelling in Colorado and New Mexico.

1926	One-man show of etchings and watercolors at St. Botolph Club, Boston. Summers in Rockland, Maine, and Gloucester, Massachusetts.
1927	Buys an automobile. Spends the summer in Two Lights, Cape Elizabeth, Maine.
1928	Paints that summer in Ogunquit and Gloucester.
1929	Second solo exhibition at Frank K.M. Rehn Gallery, comprising twelve oils, ten watercolors, and a group of drawings. Trip to South Carolina. Summers in Two Lights.
1930	Spends first summer in South Truro, Cape Cod, Massachusetts. Rents a house from farmer A.B. (Burly) Cobb, where he will return every summer through 1933.
1932	Declines nomination to associate membership in the National Academy of Design, which in earlier years had rejected his pictures. Rents additional studio space at 3 Washington Square North. Participates in first Biennale of the Whitney Museum of American Art.
1933	Travels to Quebec Province, Canada. Visits Ogunquit and Two Lights, then returns to South Truro, where he purchases land in October. Hopper retrospective at the Museum of Modern Art, New York, comprising twenty-five oils, seventy-three watercolors, and eleven etchings.
1934	Retrospective at the Arts Club of Chicago. Hopper's combination house and studio built to his own design in South Truro is finished on 9 July. The Hoppers stay there until the end of November, and will return from now on every summer.
1935-1941	Various travels, and participation in group exhibitions and selection committees on the East Coast.

1941	May to June: Automobile trip to the West Coast, through California and Oregon, and to Yellowstone National Park. Returns to South Truro in August.
1943	That summer, first train trip to Mexico, where the Hoppers stay in Mexico City, Saltillo, and Monterrey. Return in early October.
1945	Election to National Institute of Arts and Letters. From this point on, Hopper receives numerous awards and honors.
1946	Travels in May to Mexico, staying in Saltillo. Passes through the Grand Tetons on the return trip. Spends August to November in South Truro.
1950	Retrospective exhibition at the Whitney Museum of American Art, New York (also shown in Boston and Detroit).
1951	Third Mexico trip, this time by car, taking the Hoppers through Tennessee. They return by way of Santa Fe, New Mexico.

1952	Represented at the Venice Biennale. Fourth trip to Mexico, by way of El Paso, Texas. Spends a month in Mitla (near Oaxaca).
1953	Visits Puebla and Laredo, then returns in March to New York. Joins editors' committee of the journal *Reality* (a group of artists headed by Raphael Soyer and concerned to promote realistic art in New York).
1955	Fifth and final trip to Mexico.
1956	Hopper receives Huntington Hartford Foundation fellowship and goes that December to spend six months at the foundation's headquarters in Pacific Palisades, California.
1957	Returns that June from the Huntington Hartford Foundation.
1960	Meets with artists associated with the journal *Reality* to formulate a protest against the overweening influence of abstract art in the country's leading art institutions.
1962	The Philadelphia Museum of Art shows "The Complete Graphic Work of Edward Hopper."
1964	Protracted illness prevents Hopper from painting this year. The Whitney Museum of American Art mounts a retrospective, which travels to The Art Institute of Chicago.
1965	Travelling retrospective shown in Detroit and St. Louis museums. On 16 July, Hopper's sister Marion dies in Nyack. Hopper paints his two last pictures: *Chair Car* and *Two Comedians*.
1967	After long hospitalization, Hopper dies in his Washington Square studio on 15 May. His widow Josephine donates the entire estate to the Whitney Museum of American Art. She will survive her husband by less than a year.
1967-1968	From September 1967 to January 1968, Edward Hopper's work is the focus of the American contribution to the São Paulo Biennale.

Bibliography

Exhibition Catalogues

1933	The Museum of Modern Art, New York. Articles by Alfred H. Barr, Jr., Charles Burchfield, and Edward Hopper.
1950	The Whitney Museum of American Art, New York. Essay by Lloyd Goodrich.
1962	The Philadelphia Museum of Art, Philadelphia. Catalogue raisonné of the etchings, edited by Carl Zigrosser.
1964	The Whitney Museum of American Art, New York. Essay by Lloyd Goodrich.
1967	São Paulo 9; *United States of America: Edward Hopper – Environment U.S.A.* Essays by Lloyd Goodrich and William C. Seitz.
1971	The Whitney Museum of American Art, New York: *Selections from the Hopper Bequest.* Essay by Lloyd Goodrich.
1980	The Whitney Museum of American Art, New York: *Edward Hopper: The Art and the Artist.* Essay by Gail Levin.
1981	Düsseldorfer Kunsthalle, Düsseldorf. Essay by Gail Levin (German edition of the Whitney Museum catalogue).
1981	Westfälisches Landesmuseum für Kunst und Kulturgeschichte, Münster: *Edward Hopper: Das Frühwerk.* Essays by Gail Levin and Ernst G. Güse.
1992	Schirn Kunsthalle, Frankfurt am Main. Essays by Susan C. Larsen, Marc Holthof, and Paul Levine.
1992	Museum Folkwang, Essen: *Die Wahrheit des Sichtbaren – Edward Hopper und die Fotografie.* Essays by Gerd Blum, Bernd Growe, Georg-W. Költzsch, Vince Leo, Heinz Liesbrock, Joel Meyerowitz, Michael Rutschky, and Eva Schmidt.

1995	The Whitney Museum of American Art, New York: *Edward Hopper: Bilder der amerikanischen Seele*. Texts by Gail Levin.

Monographs

1970	Goodrich, Lloyd. *Edward Hopper*. Includes "Three Statements by Edward Hopper (1933, 1939, 1953)." New York: Harry N. Abrams. Reissued in 1976, 1981, and 1989.
1979	Levin, Gail. *Edward Hopper – The Complete Prints*. New York: W.W. Norton & Company.
1979	Levin, Gail. *Edward Hopper as Illustrator*. New York: W.W. Norton & Company.
1980	Levin, Gail. *Edward Hopper: The Art and the Artist*. New York: W.W. Norton & Company (see Whitney Museum catalogue above).
1985	Liesbrock, Heinz. *Edward Hopper: Die Wahrheit des Lichts*. Duisburg: Trikont.
1985	Levin, Gail. *Hopper's Places*. New York: Alfred A. Knopf.
1987	Hobbs, Robert. *Edward Hopper*. New York: Harry N. Abrams.
1988	Liesbrock, Heinz. *Edward Hopper: Vierzig Meisterwerke*. Munich: Schirmer/Mosel.
1990	Renner, Rolf Günter. *Edward Hopper – Transformation des Realen*. Cologne: Benedikt Taschen Verlag.
1992	Beck, Hubert. *Edward Hopper*. Hamburg: Eilert & Richter Verlag.
1994	Kranzfelder, Ivo. *Edward Hopper – Vision der Wirklichkeit*. Cologne: Benedikt Taschen Verlag (English edition in preparation).

Selected Essays and Articles

1964	O'Doherty, Brian. "Portrait: Edward Hopper," *Art in America*, No. 52.
1964	Campbell, Lawrence. "Hopper: Painter of 'thou shalt not'," *Art News*, October.

1968	Lanes, Jerrold. "Edward Hopper," *Artforum*, October.
1971	Mellow, James R. "The World of Edward Hopper: The Drama of Light, the Artificiality of Nature, the Remorseless Human Comedy," *New York Times Magazine*, 5 September.
1971	Robertson, Bryan. "Edward Hopper," *New York Review of Books*, 16 December.
1973	O'Doherty, Brian: "Edward Hopper," in *American Masters: The Voice and the Myth*. New York: Random House.
1980	Munhall, Edgar. "Edward Hopper und die große Krise," and Erika Billeter, "Edward Hopper und die amerikanische Szene," *Du: Die Kunstzeitschrift*, No. 4, April.
1980	Weyergraf, Bernd: "Licht von der Seite und Eyes Examined: Hopper und Marsh," in *Amerika: Traum und Depression 1920-1940*. Berlin: Neue Gesellschaft für bildende Kunst (Akademie der Künste).
1987	Schmied, Wieland. "Im Lichte Edward Hoppers," *Merian*, New York issue, November.
1992	Sager, Peter. "Straße der Nachtvögel," *Zeit-Magazin*, 26 June.
1993	Schmied, Wieland. "Precisionist View and American Scene: Die zwanziger Jahre," in *Amerikanische Kunst im 20. Jahrhundert: Malerei und Plastik 1913-1993*. Munich.
1995	Knop, Birgit. "Cape Cod: Auf den Spuren des Malers Edward Hopper," *Geo Saison*, No. 3, March.
1995	Henle, Susanne. "Mein Meistgehaßtes Meisterwerk: Hoppers Second Story Sunlight," *Frankfurter Allgemeine Zeitung*, 23 June.
1995	Schlagheck, Irma. "Edward Hopper: Das sichtbare Schweigen," *ART*, No. 7, July.

List of Illustrations

The Lighthouse at Two Lights, 1929
Oil on canvas, 29 1/2 x 43 1/4 in.
(74.9 x 109.8 cm)
The Metropolitan Museum of Art,
New York

Page 38

GIORGIO DE CHIRICO
The Great Tower, 1913
La grande torre
Oil on canvas, 48 3/4 x 20 3/4 in.
(123.8 x 52.7 cm)
Kunstsammlung Nordrhein-Westfalen,
Düsseldorf

Page 38

GIORGIO DE CHIRICO
Yearning for the Infinite, 1913-14
La nostalgia dell'infinito
Oil on canvas, 53 1/4 x 25 1/2 in.
(135.2 x 64.8 cm)
The Museum of Modern Art, New York

Page 39

Illustration from Victor Hugo's
Les Misérables, ca. 1900-09
Ink on paper, 8 x 6 1/4 in.
(20.5 x 15.9 cm)
Whitney Museum of American Art, New
York; Bequest of Josephine N. Hopper,
70.1561.190

Page 40

Illustration from Victor Hugo's
collection of poems entitled
L'Année Terrible, 1906-07 or 1909
Watercolor and ink on paper
19 1/2 x 14 3/4 in. (49.7 x 37.5 cm)
The Whitney Museum of American Art,
New York; Bequest of Josephine
N. Hopper, 70.1350

Page 40

House on a Hill (The Buggy), 1920 (?)
Etching, 8 x 10 in. (20.3 x 25.4 cm)
Philadelphia Museum of Art;
Purchased, The Harrison Fund

Page 41

New York Movie, 1939
Oil on canvas, 32 1/4 x 40 1/8 in.
(81.9 x 101.9 cm)
The Museum of Modern Art, New York

Pages 42-43

Small Town Station, 1918-20
Oil on canvas, 26 x 38 in. (66 x 96.5 cm)
The Whitney Museum of American Art,
New York; Bequest of Josephine
N. Hopper, 70.1209

Page 45

Girl at Sewing Machine, ca. 1921
Oil on canvas, 19 x 18 in.
(48.3 x 45.7 cm)
Fundación Colección Thyssen-
Bornemisza, Madrid

Page 47

New York Restaurant, ca. 1922
Oil on canvas, 24 x 29 1/8 in.
(61 x 76.2 cm)
Muskegon Museum of Art, Muskegon,
MN; Hackley Picture Fund

Page 49

Office at Night, 1940
Oil on canvas, 22 1/4 x 25 1/4 in.
(56.4 x 64 cm)
Walker Art Center, Minneapolis, MN;
Gift of the T.B. Walker Foundation,
Gilbert M. Walker Fund, 1948

Pages 50-51

ALEX COLVILLE
Truckstop, 1966
Acrylic on hardboard, 36 x 36 in.
(91.5 x 91.5 cm)
Museum Ludwig, Cologne

Page 52

EDVARD MUNCH
The Scream, 1893
Oil, gouache, casein, and crayon
on board
35 7/8 x 29 1/4 in. (91 x 74 cm)
Nasjonalgalleriet, Oslo

Page 58

RENÉ MAGRITTE
Realm of Lights, 1954
L'empire des lumières
Oil on canvas, 57 1/2 x 44 3/4 in.
(146 x 113.7 cm)
Musées Royaux des Beaux-Arts, Brussels

Page 52

Cape Cod Morning, 1950
Oil on canvas, 34 1/8 x 40 1/8 in.
(86.7 x 101.9 cm)
National Museum of American Art,
Smithsonian Institution, Washington,
D.C.; Gift of the Sara Roby Foundation
© 1994 Smithsonian Institution

Page 60

House at Dusk, 1935
Oil on canvas, 36 1/4 x 50 in.
(92.1 x 127 cm)
Virginia Museum of Fine Arts,
Richmond, VA; The John Barton Payne
Fund

Page 53

Cape Cod Afternoon, 1936
Oil on canvas, 34 1/8 x 50 in.
(86.4 x 127 cm)
Museum of Art, Carnegie Institute,
Pittsburgh, PA

Page 61

Sunday, 1926
Oil on canvas, 29 x 34 in.
(73.7 x 86.4 cm)
The Phillips Collection,
Washington, D.C.

Page 55

Cape Cod Evening, 1939
Oil on canvas, 30 x 40 in.
(76.2 x 101.6 cm)
John Hay Whitney Collection
© Board of Trustees, National Gallery of
Art, Washington, D.C.

Page 62

Nighthawks, 1942
Oil on canvas, 33 1/8 x 60 in.
(84.1 x 152.4 cm)
The Art Institute of Chicago;
Friends of American Art Collection,
1942.51
© The Art Institute of Chicago

Pages 56-57

CASPAR DAVID FRIEDRICH
Morning, ca. 1820
Der Morgen
Oil on canvas, 9 x 12 in. (22 x 30.5 cm)
Niedersächsisches Landesmuseum,
Hanover

Page 62

CASPAR DAVID FRIEDRICH
Noon, ca. 1820
Der Mittag
Oil on canvas, 8 5/8 x 11 7/8 in.
(22 x 30 cm)
Niedersächsisches Landesmuseum,
Hanover

Page 62

Cape Cod Sunset, 1934
Oil on canvas, 28 7/8 x 35 7/8 in.
(73.3 x 91.1 cm)
The Whitney Museum of American Art,
New York; Bequest of Josephine
N. Hopper, 70.1166

Page 63

CASPAR DAVID FRIEDRICH
Afternoon, ca. 1820
Der Nachmittag
Oil on canvas, 8 5/8 x 12 1/4 in.
(22 x 31 cm)
Niedersächsisches Landesmuseum,
Hanover

Page 63

CASPAR DAVID FRIEDRICH
Evening, ca. 1820
Der Abend
Oil on canvas, 8 7/8 x 12 1/4 in.
(22.5 x 31 cm)
Niedersächsisches Landesmuseum,
Hanover

Page 63

Five A.M., ca. 1937
Oil on canvas, 25 x 36 in.
(63.5 x 91.4 cm)
Wichita Art Museum, Wichita, KS

Pages 1, 64-65

Night Windows, 1928
Oil on canvas, 29 x 34 in.
(73.7 x 86.4 cm)
The Museum of Modern Art, New York;
Gift of John Hay Whitney

Page 66

Eleven A.M., 1926
Oil on canvas, 28 x 36 in.
(71.3 x 91.6 cm)
Hirshhorn Museum and Sculpture
Garden, Smithsonian Institution,
Washington, D.C.; Gift of the Joseph
H. Hirshhorn Foundation, 1966,
66.2504

Page 67

Conference at Night, 1949
Oil on canvas, 27 3/4 x 40 in.
(70.5 x 101.6 cm)
Courtesy of the Wichita Art Museum,
Wichita, KS; Roland P. Murdock
Collection

Pages 68-69

Hotel Lobby, 1943
Oil on canvas, 32 1/2 x 40 3/4 in.
(82.5 x 103.5 cm)
Indianapolis Museum of Art, India-
napolis, IN; William Ray Adams
Memorial Collection

Pages 70-71

Summertime, 1943
Oil on canvas, 29 1/8 x 44 in.
(74 x 111.8 cm)
Delaware Art Museum, Wilmington,
DE; Gift of Dora Sexton Brown, 1962

Page 72

High Noon, 1949
Oil on canvas, 28 x 40 in.
(71.1 x 101.6 cm)
The Dayton Art Institute, Dayton, OH
Page 73

Morning in a City, 1944
Oil on canvas, 44 x 60 1/4 in.
(112 x 153 cm)
Williams College Museum of Art,
Williamstown, MA; Bequest of
Lawrence H. Bloedel, Class of
1923, 77.9.7
Page 75

A Woman in the Sun, 1961
Oil on canvas, 28 x 60 1/4 in.
(101.6 x 152.4 cm)
The Whitney Museum of American Art,
New York; 50th Anniversary Gift of
Mr. and Mrs. Albert Hackett in honor
of Edith and Lloyd Goodrich, 84.31
Page 77

Hotel Room, 1931
Oil on canvas, 60 1/4 x 65 1/4 in.
(152.4 x 165.7 cm)
Fundación Colección Thyssen-
Bornemisza, Madrid
Page 78

Morning Sun, 1952
Oil on canvas, 28 1/8 x 40 1/8 in.
(71.4 x 101.9 cm)
Columbus Museum of Art, Columbus,
OH; Museum Purchase: Howald Fund
Page 79

Seven A.M., 1948
Oil on canvas, 30 x 40 1/8 in.
(76.2 x 101.6 cm)
The Whitney Museum of American Art,
New York; Purchase and exchange, 50.8
Pages 80-81

Room in Brooklyn, 1932
Oil on canvas, 28 3/4 x 34 in.
(73.6 x 86.3 cm)
Museum of Fine Arts, Boston;
The Hayden Collection
Page 82

Automat, 1927
Oil on canvas, 28 1/8 x 36 in.
(71.4 x 91.4 cm)
Des Moines Art Center, IA;
James D. Edmundson Fund, 1958.2
Page 83

Compartment C, Car 293, 1938
Oil on canvas, 20 x 17 7/8 in.
(50.8 x 45.7 cm)
IBM Corporation, Armonk, NY
Page 85

The Camel's Hump, 1931
Oil on canvas, 32 1/4 x 50 1/8 in.
(81.9 x 127.3 cm)
Munson-Williams-Proctor Institute,
Museum of Art, Utica, NY;
Bequest of Edward W. Root
Page 86

Road and Houses, South Truro, 1930-33
Oil on canvas, 27 x 43 in.
(68.6 x 109.2 cm)
The Whitney Museum of American Art,
New York; Bequest of Josephine
N. Hopper, 70.1212
Page 87

Railroad Crossing, 1922-23
Oil on canvas, 29 x 40 in.
(73.7 x 101 cm)
The Whitney Museum of American Art,
New York; Bequest of Josephine
N. Hopper, 70.1189

Page 88

Sunlight on Brownstones, 1956
Oil on canvas, 29 3/4 x 40 in.
(75.6 x 101 cm)
Wichita Art Museum, Wichita, KS;
The Roland P. Murdock Collection

Page 89

Sunlight in a Cafeteria, 1958
Oil on canvas, 40 1/4 x 60 1/8 in.
(102.2 x 152.7 cm)
Yale University Art Gallery, New Haven,
CT; Bequest of Stephen Carlton Clark,
B.A., 1903

Pages 90-91

Western Motel, 1957
Oil on canvas, 30 1/4 x 50 1/8 in.
(76.8 x 127.3 cm)
Yale University Art Gallery, New Haven,
CT; Bequest of Stephen Carlton Clark,
B.A., 1903

Pages 92-93

FREDERIC EDWIN CHURCH
Twilight in the Wilderness, 1860
Dämmerung in der Wildnis
Oil on canvas, 40 x 64 in.
(101.6 x 162.5 cm)
The Cleveland Museum of Art,
Cleveland, OH; Mr. and Mrs. William
H. Marlatt Fund, CMA 65.233

Page 94

Railroad Sunset, 1929
Oil on canvas, 28 1/2 x 47 3/4 in.
(72.4 x 121.3 cm)
The Whitney Museum of American Art,
New York; Bequest of Josephine
N. Hopper, 70.1170

Page 95

Hills, South Truro, 1930
Oil on canvas, 27 3/8 x 43 1/8 in.
(69.5 x 109.5 cm)
The Cleveland Museum of Art,
Cleveland, OH; Hinman B. Hurlbut
Collection, 2647.31

Page 96

New York, New Haven and Hartford, 1931
Oil on canvas, 32 x 50 in.
(81.3 x 127 cm)
© 1993 Indianapolis Museum of Art,
Emma Harter Sweetser Fund, 32.177

Page 97

Second Story Sunlight, 1960
Oil on canvas, 40 x 50 in.
(101.6 x 127 cm)
The Whitney Museum of American Art,
New York; Purchased with funds from
the Friends of the Whitney Museum of
American Art, 60.54

Pages 98-99

Approaching a City, 1946
Oil on canvas, 27 x 36 in.
(68.6 x 91.4 cm)
The Phillips Collection,
Washington, D.C.

Page 101

New York Office, 1962
Oil on canvas, 40 x 55 in.
(101.6 x 139.7 cm)
Collection of the Montgomery Museum
of Fine Arts, Montgomery, AL;
The Blount Collection

Pages 102-103

People in the Sun, 1960
Oil on canvas, 40 3/8 x 60 3/8 in.
(102.6 x 153.4 cm)
National Museum of American Art,
Smithsonian Institution, Washington,
D.C.; Gift of S.C. Johnson & Son,
Inc./Art Resource, New York

Page 104

South Carolina Morning, 1955
Oil on canvas, 30 x 40 in.
(76.2 x 101.6 cm)
The Whitney Museum of American Art,
New York; Given in memory of Otto
L. Spaeth by his family, 67.13

Page 106

New York Corner (Corner Saloon), 1913
Oil on canvas, 24 x 29 in. (61 x 73.7 cm)
The Museum of Modern Art, New York;
Abby Aldrich Rockefeller Fund

Page 107

Self-Portrait, 1925-30
Oil on canvas, 28 1/8 x 20 1/4 in.
(63.8 x 51.4 cm)
The Whitney Museum of American Art,
New York; Bequest of Josephine
N. Hopper, 70.1165

Page 109

Jo Painting, 1936
Oil on canvas, 18 x 16 in.
(47.7 x 40.6 cm)
The Whitney Museum of American Art,
New York; Bequest of Josephine
N. Hopper, 70.1171

Page 109

Street Scene, Gloucester, 1934
Oil on canvas, 28 1/4 x 36 in.
(71.7 x 91.4 cm)
Cincinnati Art Museum, Cincinnati,
OH; The Edwin and Virginia Irwin
Memorial, 1959.49

Pages 4, 110

Dawn in Pennsylvania, 1942
Oil on canvas, 24 3/8 x 44 1/4 in.
(61.9 x 112.4 cm)
Courtesy of Terra Museum of American
Art, Chicago; Daniel J. Terra Collection,
18.1986
© All rights reserved

Page 112

Photo Credits

Front cover: *High Noon*, 1949 (detail; see illus. p. 73)
Spine: *Chop Suey*, 1927 (detail), oil on canvas, 32 1/8 x 38 in.
(81.6 x 96.8 cm)
Frontispiece: Edward and Jo Hopper in South Truro, 1960,
© 1980 Arnold Newman

Translated from the German by John William Gabriel

Prestel-Verlag
Mandlstrasse 26, D-80802 Munich, Germany
Tel. (89) 38 17 09-0; Fax (89) 38 17 09-35
and 16 West 22nd Street, New York, NY 10010, USA
Tel. (212) 627-8199; Fax (212) 627-9866

Prestel books are available worldwide. Please contact your nearest bookseller or write
to either of the above addresses for information concerning your local distributor.

Lithography by Reprographia, Lahr
Typeset by Design-Typo-Print, Ismaning
Printed and bound by Passavia, Passau
Typeset in Janson

Printed in Germany

ISBN 3-7913-1485-8 (English edition)
ISBN 3-7913-1480-7 (German edition)